IMAGES
of America

HAYDEN

IMAGES
of America

HAYDEN

Jan Leslie and the
Hayden Heritage Center

ARCADIA
PUBLISHING

Published by Arcadia Publishing
Charleston SC, Chicago IL, Portsmouth NH, San Francisco CA

Printed in the United States of America

Library of Congress Control Number: 2009934869

For all general information contact Arcadia Publishing at:
Telephone 843-853-2070
Fax 843-853-0044
E-mail sales@arcadiapublishing.com
For customer service and orders:
Toll-Free 1-888-313-2665

Visit us on the Internet at www.arcadiapublishing.com

The Hayden Heritage Center would like to dedicate this book to the primary author, Jan Leslie, who has worked tirelessly to accurately preserve Hayden's history.

CONTENTS

Acknowledgments 6

Introduction 7

1. The First People In 9

2. Beginning Strides: 1900–1910 23

3. Gathering Steam: The "Teen" Years 37

4. Settling Down: The 1920s 67

5. Hanging in There: The 1930s 81

6. Small Town: The 1940s 91

7. Mount Harris 95

8. People 113

Bibliography 126

About the Hayden Heritage Center 127

ACKNOWLEDGMENTS

The Hayden Heritage Center would like to acknowledge that this book would not have been possible without the countless hours of research by its primary author, Jan Leslie. Her determination to provide accurate information to accompany the photographs of her choosing makes this an invaluable and reliable guide to Hayden's history. The kind donors who provided photographs to the museum also deserve a heartfelt "thank you" for their generosity in sharing their images for this book. The museum's Board of Directors (Jerry and Judy Green, Sharon Jost, Rebecca Wattles, Diane Holly, and Jody and Erin Babcock) graciously allowed for the many man-hours needed to complete this project, and gave willingly of their time to that end. Unless otherwise noted, all images appearing in this book are from the Hayden Heritage Center Photograph Collection.

INTRODUCTION

"The valley of the Yampah is the finest and most promising of the whole district," wrote Story B. Ladd in 1875. "It is in this valley that the new settlement of Haydenville is started, the beginning being made November last [1874]." Ladd was a member of Ferdinand V. Hayden's surveying party, which camped in the area in 1873 and 1874.

Hayden was the remote headquarters of Porter M. Smart's Western Colorado Improvement Company, which was organized at Hot Sulphur Springs in August 1874. It was a promotional scheme of epic proportions that included town sites, roads, railroads, telegraphs, farms, ferries, and ranches. Porter Smart and his two sons, Gordon and Albert, arrived in the Hayden area in November 1874 and built a cabin just north of the present site of Hayden.

The first post office in northwestern Colorado was established at Hayden on November 15, 1875, with Albert Smart as postmaster. Albert—and later his wife, Lou—operated the post office in their cabin south of the Yampa River. On the application for establishing the post office, Smart optimistically estimated that the post office would serve 125 patrons, but it would be years before there were that many settlers in the area.

At the time, Hayden was located in the westernmost part of Grand County. On January 29, 1877, Governor John L. Routt, the last territorial governor and the first elected governor of Colorado, signed the bill establishing the county which bore his name.

Departing from the usual procedure of establishing new counties, the legislators did not designate a county seat. Instead, the appointed county commissioners—Gordon Smart of Hayden, A. J. Bell of Hahns Peak, and Thomas Iles from Elkhead, east of Craig—were to decide upon a temporary site until an election could be held. Their choice was Hayden, possibly because of its central location.

The election of 1877 resulted in no clear choice, so the seat of government remained at Hayden. Although Hahns Peak became the county seat in 1878, the county records were not moved until May 1, 1879.

On September 27, 1879, a Ute uprising at the White River Agency (near the present town of Meeker) resulted in the death of agent Nathan Meeker and five male employees. When news of the massacre reached the Yampa Valley, settlers along the river threw a few supplies into wagons and gathered at the James Crawford cabin in Steamboat Springs.

Once the peaceful Yampatika (whose hunting ground was the Yampa Valley) and other bands of Utes were moved to reservations in Utah in 1881, the settlers began to arrive in the valley. Although the Yampa Valley was not in Ute territory, the Native American presence had been a deterrent to settlement.

William R. Walker from Hiawassee, Georgia, arrived in 1881 and, by a preemption claim, took up a ranch southwest of Hayden. Later, he sold the property and took up a homestead claim

north of Hayden. Part of the homestead was the former site of Albert Smart's cabin and the first Hayden post office. In 1894, William Walker and neighbor Ephus Doneslon platted the original town site of Hayden on their respective ranches.

With the arrival of Ezekiel Shelton in 1882, Routt County had its first surveyor. A year earlier, Denver capitalists had hired the Ohioan to investigate reports of coal beds in northwestern Colorado. Shelton was the first to provide definitive information on the coal-bearing formations in the area. As county surveyor, Shelton surveyed the first three roads in the county. The first road connected Hayden and Steamboat Springs and was north of present U.S. Highway 40. The next one ran southeast from Hayden through Twentymile Park to Yampa and Toponas and on to the top of the Gore Range in the southern part of the county. A third road was laid out between Hayden and Craig, some 17 miles west, where it connected with the stage road between Rawlins, Wyoming, and Meeker. Until the winter of 1882–1883, when a bridge over the Yampa River was built, travelers had to ford the river to reach Hayden.

On May 24, 1887, Hayden School District No. 2 was established by John T. Whyte, Routt County's superintendent of schools. Whyte, who died in 1888, holds the dubious distinction of being the first to be buried in the cemetery at Hayden.

By 1889, Hayden had a log one-room school, two large general merchandise stores, two saloons, a drug store, planing mill, shoe shop, blacksmith, livery stable, and two hotels. Two lodges, the Independent Order of Odd Fellows and Woodmen of the World, had been established. In 1900, the log school was replaced by a two-story frame building that accommodated both an elementary and a high school. In 1902, the Bank of Hayden and the Yampa Valley Bank were organized, and Sam Fletcher began construction of a Congregational church, which was the first church in town.

On March 13, 1906, an election to incorporate was held in Hayden, and despite a howling blizzard, 95 votes were cast. Of these, only two voters opposed the proposition. Robert Norvell was elected mayor, and Alonzo P. Wood, Christian Schaefermeyer, Harry Wood, J. E. Downs, Charles Fiske, and Samuel Fletcher served on the first board of trustees. Hayden residents voted to "go dry" by local option in November 1908. The town remained dry until the Prohibition era ended in 1933.

Ever since 1902, when David Moffat announced his intention to build a railroad from Denver to Salt Lake City, Hayden residents had been anticipating its arrival. By 1906, the Denver, Northwestern and Pacific had gotten no further than Kremmling—and there it stopped. In an effort to attract investors, Moffat designated Hayden as its division headquarters, and on July 29, 1908, the West Hayden Townsite was incorporated. The town experienced a building boom as businesses moved to the developing site, but the railroad did not arrive until 1913.

However, Hayden continued to prosper. The town finally got a depot in 1918. The facility operated until passenger service was cancelled in 1968. Today, the building is the home of the town's museum, the Hayden Heritage Center. In 1919, construction began on a modern, two-story high school, and in April 1923, Solandt Memorial Hospital opened its doors. Hayden Station, a coal-fired generating plant, went online in 1965, and a year later, construction began on Yampa Valley Regional Airport. Both are located on a mesa east of Hayden.

Today, Hayden is sometimes referred to as a "bedroom community" for the year-round resort community of Steamboat Springs. For families and people still involved in local agriculture, the energy industry, and town life, it is still truly a home with a history and a future, nestled among the wild beauties of the Rocky Mountain foothills, the lovely Yampa River, and the wide open Western spaces.

One

THE FIRST PEOPLE IN

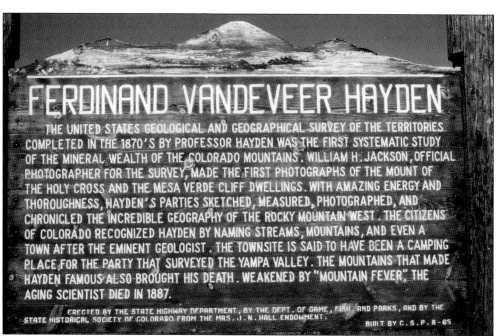

FERDINAND VANDEVEER HAYDEN

THE UNITED STATES GEOLOGICAL AND GEOGRAPHICAL SURVEY OF THE TERRITORIES COMPLETED IN THE 1870'S BY PROFESSOR HAYDEN WAS THE FIRST SYSTEMATIC STUDY OF THE MINERAL WEALTH OF THE COLORADO MOUNTAINS. WILLIAM H. JACKSON, OFFICIAL PHOTOGRAPHER FOR THE SURVEY, MADE THE FIRST PHOTOGRAPHS OF THE MOUNT OF THE HOLY CROSS AND THE MESA VERDE CLIFF DWELLINGS. WITH AMAZING ENERGY AND THOROUGHNESS, HAYDEN'S PARTIES SKETCHED, MEASURED, PHOTOGRAPHED, AND CHRONICLED THE INCREDIBLE GEOGRAPHY OF THE ROCKY MOUNTAIN WEST. THE CITIZENS OF COLORADO RECOGNIZED HAYDEN BY NAMING STREAMS, MOUNTAINS, AND EVEN A TOWN AFTER THE EMINENT GEOLOGIST. THE TOWNSITE IS SAID TO HAVE BEEN A CAMPING PLACE FOR THE PARTY THAT SURVEYED THE YAMPA VALLEY. THE MOUNTAINS THAT MADE HAYDEN FAMOUS ALSO BROUGHT HIS DEATH. WEAKENED BY "MOUNTAIN FEVER", THE AGING SCIENTIST DIED IN 1887.

ERECTED BY THE STATE HIGHWAY DEPARTMENT, BY THE DEPT. OF GAME, FISH, AND PARKS, AND BY THE STATE HISTORICAL SOCIETY OF COLORADO FROM THE MRS. J.N. HALL ENDOWMENT.
BUILT BY C.S.P. 8-65

Hayden is located in the beautiful Yampa Valley, and is named for Ferdinand Vandeveer Hayden, head of the United States Geological and Geographic Survey. Members of the Hayden survey camped in the area in 1873 and 1874. The first post office in present Routt County was established here on November 15, 1875, with Albert Smart as postmaster. Hayden was incorporated on March 13, 1906, and celebrated its centennial in 2006.

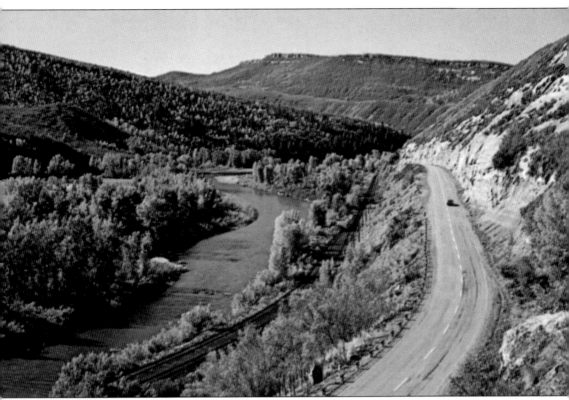

The largest river in Routt County rises on the east side of the White River Plateau above Yampa and meanders north through Pleasant Valley to Steamboat Springs, and then west through Hayden and Craig to the Green River near the Utah line. This river, known throughout the county, suffered from the disadvantage of having two names. For hundreds of years, it had been known by the Utes as the "Yampa," named for a plant they dried and used as food. In 1890, the United States Board of Geographical Names stated that the official name of the river was the Yampa River, but as late as 1907, there were still some who referred to it as the Bear River. For this reason, the Yampa River flows through the Bear River Canyon east of Hayden. This view of the Yampa River was taken in the canyon.

The first Routt County courthouse was located just north of Hayden. Maj. James B. Thompson, the first county treasurer, built this temporary structure to house the county records. Although the election of 1878 located the county seat at Hahns Peak, the records remained at Hayden until May 1, 1879. The building was moved to the Routt County Fairgrounds in the 1920s, and was accidentally destroyed in 1965.

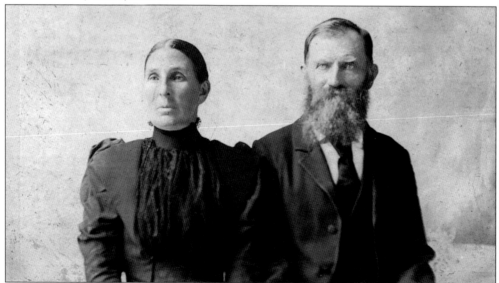

The arrival of Samuel and Mary Reid in 1880 marks the beginning of Hayden's recorded history. The Hayden post office, which had been discontinued after the Ute uprising in 1879, was reestablished on the Reid homestead south of Hayden in 1880. Mary Reid served as postmaster until 1890 when her daughter, Martha Donelson, succeeded her. The first school in the area was also located on the homestead.

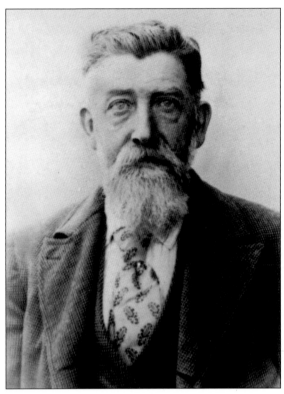

William Walker was born in North Carolina and served in the Confederate Army during the Civil War. His first wife, Nancy Reid, passed away during the first year of that war, and after the war ended, he married Angelina Burch. Lured west by letters from his brother-in-law, Sam Reid, he came to Hayden in 1881 and settled on a homestead claim south of town.

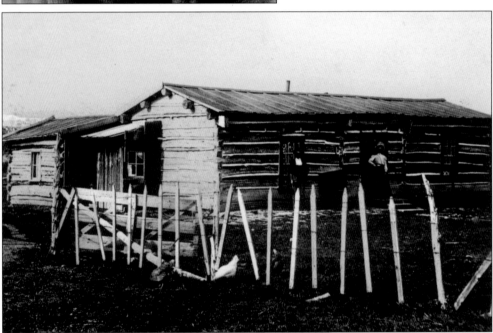

Through a preemption claim, William Walker filed on 160 acres north of Hayden, and in 1882, he built this cabin. The lane between the homestead and his pastures south of town became the present Walnut Street. Part of the original town of Hayden was platted on his ranch in 1894. Walker, a staunch Democrat, served as Routt County commissioner from 1882 to 1884.

Ezekiel Shelton, who is shown here with his wife, Mary, was investigating reports of coal when he came to the area in 1881. The following year, Ezekiel and his son Byron left their Ohio home to set up a homestead in the Yampa Valley. As the first county surveyor, he surveyed the first roads in the county and served as Routt County superintendent of schools from 1889 to 1890.

Ezekiel Shelton and his wife, Mary, sit in front of their log home with its pole-and-dirt roof, which Ezekiel and his son, Byron, built in 1882. Before Mary arrived in Hayden in October 1883, Byron went to a sawmill near Steamboat Springs to get rough boards for the cabin floor. He had to ford the river 13 times on the 25-mile trip. (Courtesy of Tread of Pioneers Museum.)

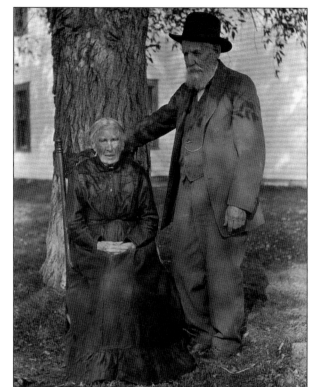

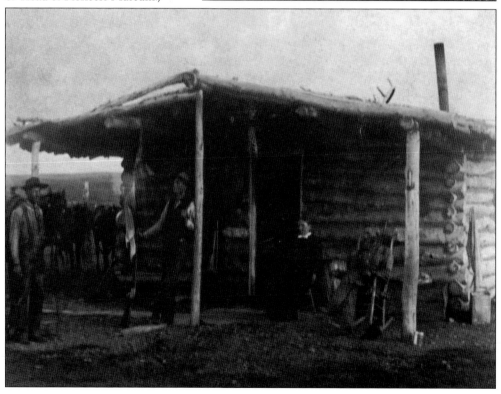

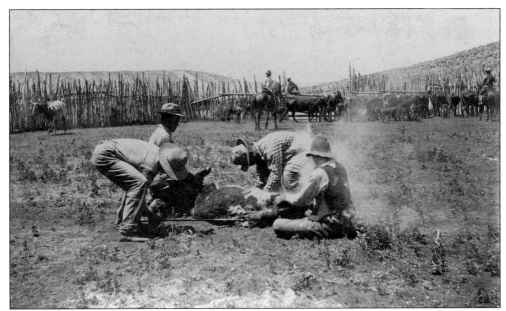

Pioneer wildlife photographer A. G. Wallihan took numerous photos of early Routt County pioneer life in addition to his noted wildlife shots. This photograph captured the hot, dirty work of branding in the western portion of Routt County around 1890. The corral fence in the background was made from cedar posts cut from trees in the nearby hills.

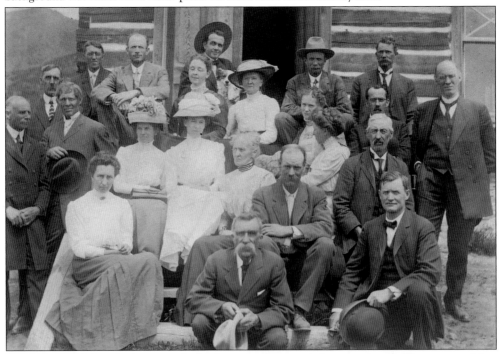

James Norvell (white hat) was a colorful figure in the county for more than half a century. After his arrival in 1882, he was a cowboy, mail carrier, merchant, town and addition promoter, and rancher. He devoted time to church work and was an evangelist known as the "Cowboy Preacher." He posed here with a church group in 1911.

Prior to the arrival of the Moffat Road railroad in 1913, small wagon mines supplied coal to the Hayden area. Two or three men usually operated the mine, and coal was sold not by the ton, but by the wagonload. The Jimmy Dunn Mine, shown here, was noted for its excellent grade of coal and was located in the Elkhead country north of Hayden.

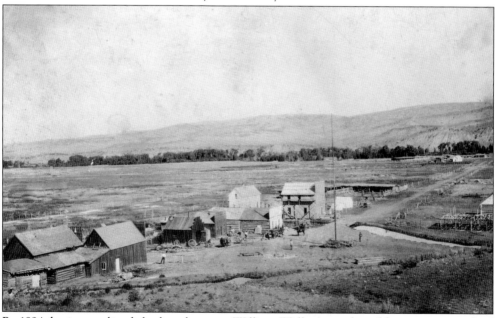

By 1894, businesses lined the lane between William Walker's ranch and his pastures south of town. The building in the left foreground was a restaurant that advertised, "Donelson Avenue and Walker Street, John X Restaurant and nothing to eat." Across Donelson Avenue stood a blacksmith shop owned by Dryer and Newburg. The next building was Carley and Jones Mercantile. The three-story Central Hotel, built by E. D. Smith, was under construction. (Courtesy of Museum of Northwest Colorado.)

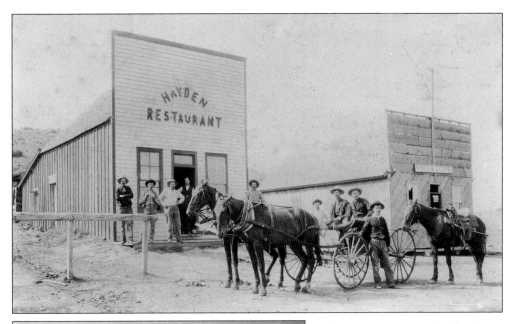

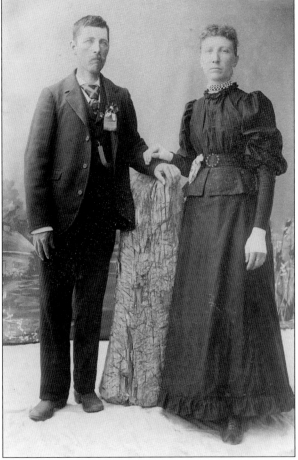

John Rawson Turner, familiarly known as "John X.," owned the first restaurant in Hayden. Turner, who was born in London, England, left after the restaurant burned down in 1894 or 1895. The building next door was Rube Wiley's saloon. When Wiley decided to become a preacher, he sold the building to Christof Baierl. A German immigrant who came to Hayden in 1895, Baierl turned the former saloon into a blacksmith shop.

Henry Kitchens married William Walker's niece, Sarah, in 1893, and a year later, he built the first livery barn in Hayden. The site for the livery barn may have been a wedding present, or Walker may have seen a need for a livery in the newly platted town and gave the land to Henry to build it. Sarah died of typhoid in 1897.

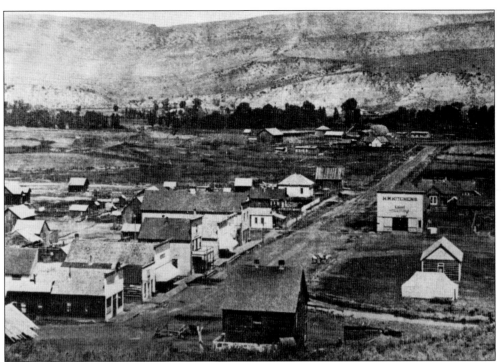

Henry Kitchens's livery barn (center right) was the only building on the east side of Walnut Street in this 1901 photograph. The little log school building at lower right, which had been replaced by a new frame building, was being used as a church. It sat alone, north of the Shelton Ditch, until 1903, when more businesses were established.

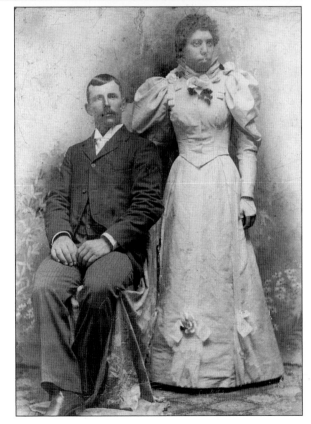

William Kleckner walked into Routt County from Rawlins, Wyoming, in 1890. He married Ida Kitchens in 1895, and the couple lived on a ranch west of Hayden until 1911, when they moved to a ranch near the Bears Ears. In 1921, three years after Ida died, William bought the livery barn in Hayden and operated it until he retired in 1944. (Courtesy of Judy Poteet.)

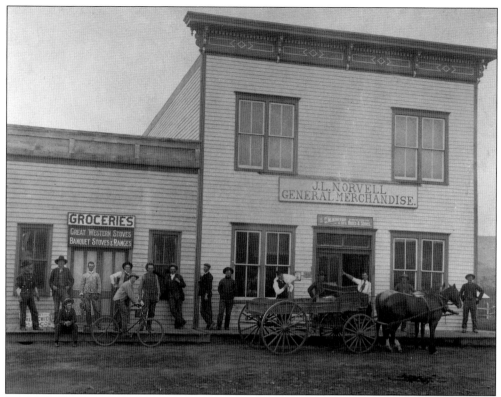

J. L. Norvell's general merchandise store was started about 1895 by James Lafayette Norvell. The store had one of the first three telephones in Routt County. Norvell hired his brother Robert and Byron Shelton to run the business, and when the firm incorporated in 1902, the three men became partners. After his first marriage ended in divorce, Norvell sold his house in Hayden and moved to Steamboat Springs.

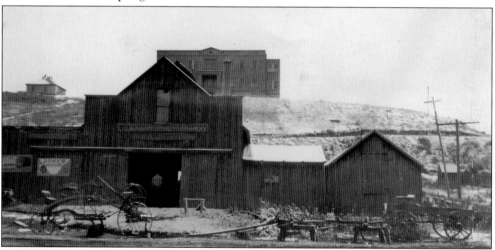

This building was originally Hayden's first saloon. Christof Baierl, who was born in Germany, bought it in 1895 and used it for a blacksmith shop. He operated the Hayden Blacksmith and Wagon Shop until his death in 1936. The building on the hill is the Solandt Memorial Hospital, which opened for business in 1923.

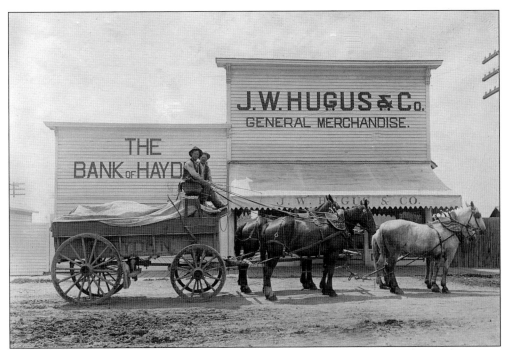

J. W. Hugus and Company, a chain of general merchandise stores, opened a store in Hayden in 1894. In October 1902, the Bank of Hayden opened for business. The Hugus Company, which owned the bank, moved it into a building adjoining the store in 1909. Ira Smith (front), who frequently hauled freight for Hugus, and Ed Knowles stopped in front of the building on Walnut Street for this 1910 photograph.

Dr. B. L. Jefferson became Hayden's first resident doctor in 1895. Three years later, he moved to Steamboat Springs. In 1900, Jefferson was elected to the state House of Representatives. He later served two terms as a Colorado state senator, and was appointed registrar of the State Land Board. On June 13, 1913, he received an appointment as U.S. ambassador to Nicaragua.

Dr. John Vernon Solandt, a Canadian, arrived in Hayden in 1898. Like most country doctors everywhere, he often made long trips to visit his patients. Sometimes he rode horseback and other times he used a sleigh. Later he would use an automobile when the roads were passable. One night while returning from a call, the headlights went out in the automobile in which he was riding. The car rolled, pinning the doctor underneath it. Dr. Solandt died of his injuries on September 14, 1916. The community never forgot the doctor who had been so well-loved by those he served. After World War I, the community rallied to build a hospital that would bear his name. The Solandt hospital building still stands today on a hill overlooking Hayden—a quiet testimony to the dedication of this beloved doctor to his community.

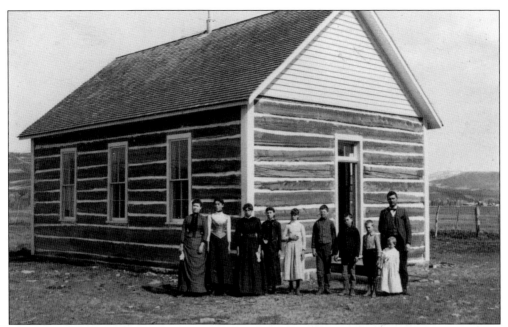

The first permanent schoolhouse in Hayden was built by the community in 1889. Ed Stees (right) was paid $65 a month for teaching a four-month term in 1889 and 1890. After a new school was built in 1900, the Congregational Church purchased the building and services were held there until 1903, when the Hayden Congregational Church was completed.

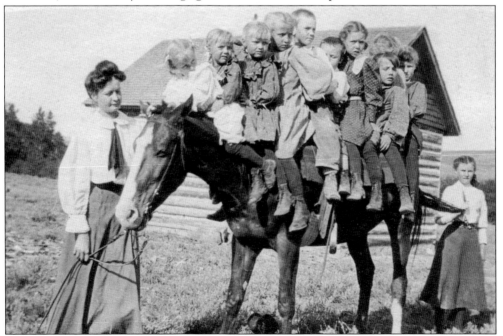

Students at the Upper Hayden School just east of Hayden climbed aboard a horse for this image. The teacher, Paroda Bailey, married Elkhead homesteader Charles Fulton in 1908. They later moved onto a ranch just north of Hayden. In 1932, she became the first librarian at the Hayden Public Library and served in that capacity until March 1950. (Courtesy of the Fulton Family.)

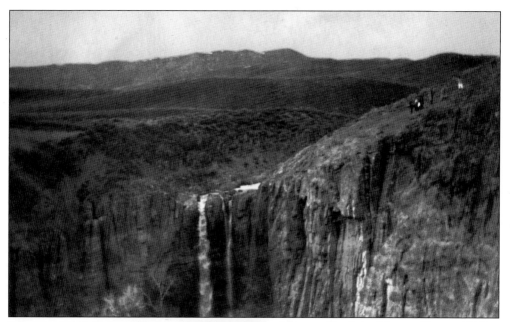

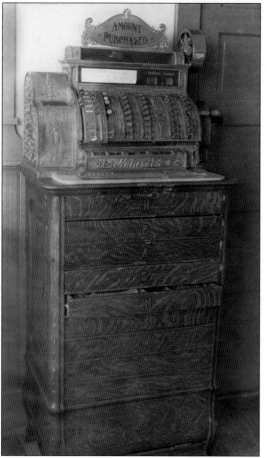

Morgan Creek (or Morgan Bottom) Falls, northeast of Hayden, is a phenomenon that occurs only in the spring. At that time of the year, Morgan Creek overflows its banks and plunges into the canyon below. Both the falls and the area known as Morgan Bottom are named for the Morgan brothers, who came to the valley in 1873.

As the first decade of the 20th century began, business was brisk for the small businesses in Hayden. James Norvell felt the pressing need to order a state-of-the-art cash register to handle his mercantile business more efficiently. The highly decorative and extremely modern piece of machinery could keep detailed records of all sales, and even kept account of orders taken by individual salesclerks.

Two

BEGINNING STRIDES
1900–1910

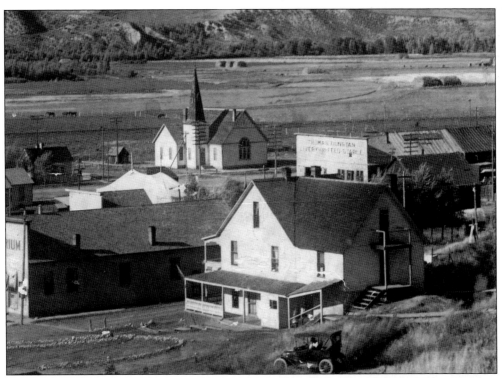

The Oxford Hotel was first known as the Hayden Hotel. In 1902, when Anna and Clint Bowman bought it, it was the Roberts House. Bowman was the consummate hotelier, and the hotel soon became one of the finest in the county. After the third floor was damaged by a fire in September 1922, the hotel was sold to Byron Shelton. It reopened in April 1923 as the Tavern Hotel.

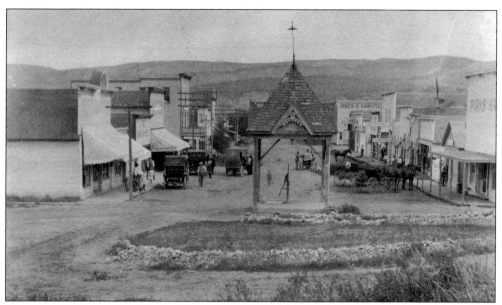

Businesses and townspeople who did not have their own wells got their water from the town pump. It sat squarely in the intersection below the Oxford Hotel, a block south of what is now Highway 40. It was housed in a cement-floored building with a peaked roof, and looked like a small-town bandstand. The town pump was the focal point from which directions were given to newcomers.

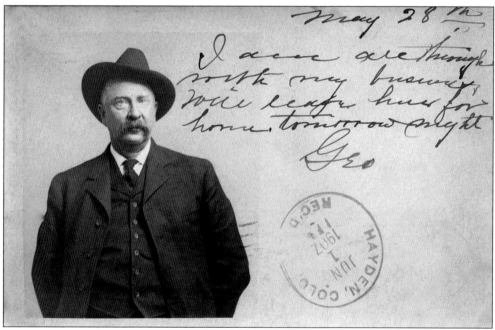

George Anderson sent this postcard to his wife, Cora, in 1907. A former saloonkeeper in Hahns Peak, he bought Andy Underwood's saloon in Hayden in 1900. His new business, the Hayden Exchange, operated until the town voted to "go dry" in 1908. Anderson then went into the hardware business. (Courtesy of Judy Poteet.)

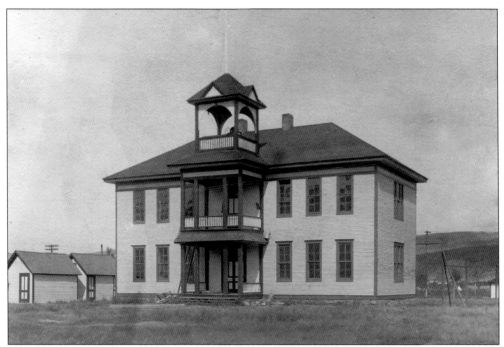

Samuel Fletcher completed the new Hayden school in 1900. It was built facing Washington Avenue, which was the main east-west thoroughfare at the time. Mattie Walker, who taught grades one through three, was the first teacher. The school's bell was also used to call worshippers to church services, and as a fire alarm.

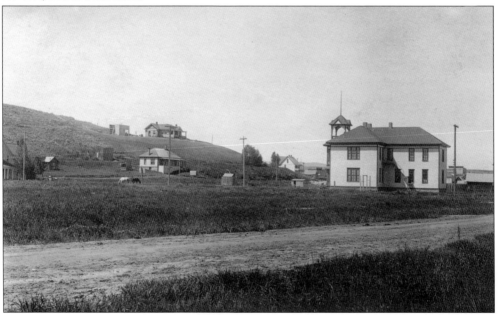

High school classes were added to the Edison School in 1902, with R. C. Drake as principal. In 1912, the school was so crowded that the directors advertised for bids on the construction of the addition seen here. The bids were too high, so Samuel Fletcher was hired to frame the addition, and local carpenters finished it.

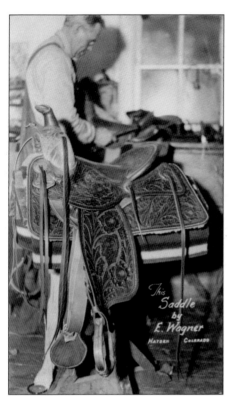

Ernest Wagner rode into town on a bicycle in 1901. He came from Denver, where he had learned the saddle and harness trade. Setting up shop in Hayden, he soon earned a reputation for his famous "Routt County Saddle." Changing with the times, he later began selling furniture and large appliances. Wagner, who died in 1940, devoted the last few years of his life to improving the Hayden Cemetery.

Ernest Wagner, shown here with his wife, Jean, was much more than a saddle maker. Each year as Christmas drew near, he gathered old or broken toys to be mended, repaired, and painted. These toys were given to children in the community who otherwise might not have a Christmas. Ernest had just issued his annual call for old or worn toys when he passed away on November 24, 1940.

In October 1901, Samuel Fletcher was awarded the contract to build a Congregational church. It was to be 35 by 50 feet, with a 16-by-20-foot lecture room. Although construction began during Reverend Singleton's tenure here, he had been replaced by Rev. Frank Hullinger by the time the church was dedicated on May 28, 1903. (Courtesy of the Fulton Family.)

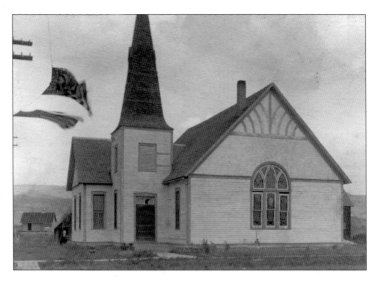

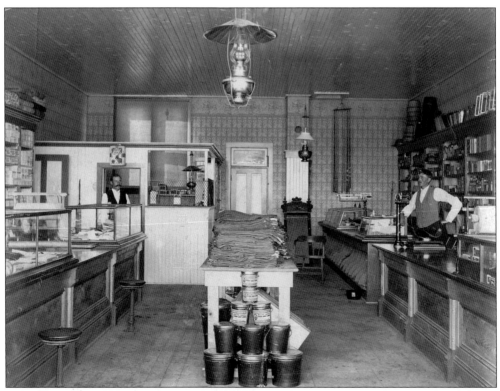

The Yampa Valley Bank was located in a corner of the Norvell Mercantile store. The bank was started in 1902 by F. Emery Milner, who owned the Milner Bank and Trust in Steamboat Springs, and was the first bank in the county organized under state law. Manuel "Mac" Burch (left) was the cashier and general manager of the bank.

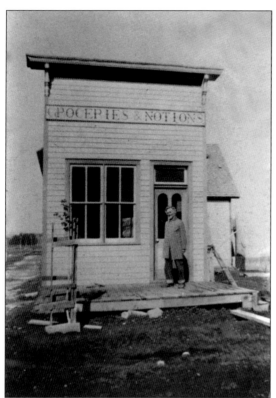

Christian Schaefermeyer and his wife, Eliza Taft Schaefermeyer, came to Hayden from Sedalia, Colorado, in 1902. He owned and operated a small grocery and general merchandise store on the northwest corner of Walnut and Jefferson Avenue. Children would come to his store to turn in the tiny horseshoe labels from Horseshoe Chewing Tobacco, at two for a penny, to buy candy.

In the fall, residents began laying in a supply of venison for the winter by camping near the paths that deer followed to their winter forage grounds. In this *c.* 1905 photograph, a successful hunter has stopped by the drugstore owned by Dr. Downs on Walnut Street (right). The building in the center of the photograph is Samuel Fletcher's carpenter shop. To the left of the drugstore is Christof Baierl's blacksmith shop.

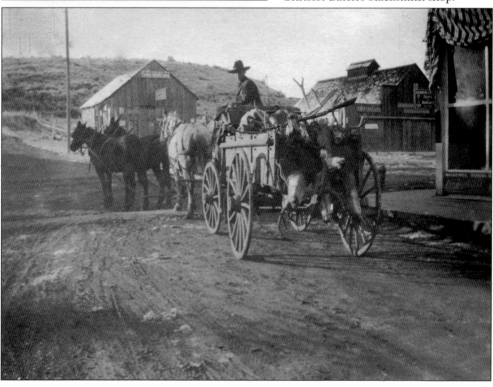

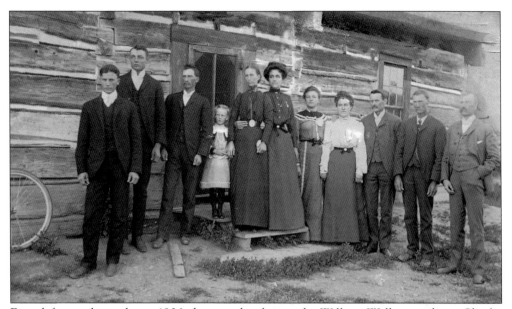

From left to right in this *c.* 1906 photograph taken at the William Walker ranch are Charlie Sellers, Orval Kitchens, Henry Sellers, Pearl Day, Mary Day, Mattie Summer, Bertha Sellers, Ida Kleckner, George Kleckner, George Day, and Dave Sellers. Dave Sellers (married to Bertha Sellers) owned the ranch. Dave was a brother of Mary Day and Henry Sellers. Mattie Summer, Bertha Sellers, and Ida Kleckner were sisters.

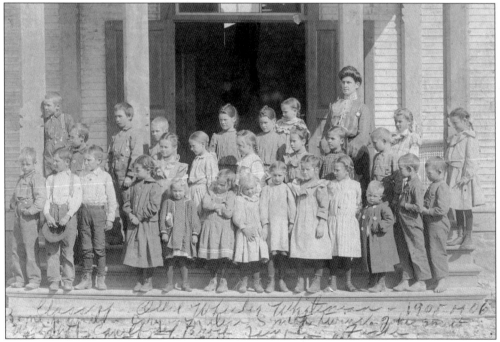

Ollie (Olive) Wheeler and her primary students lined up on the front steps of the Edison School for this 1906 photograph. Wheeler and her sister, Florence, came to spend the summer of 1901 visiting a brother who lived in Hayden. The new school was ready for occupancy at that time, and Ollie remained in town and taught the primary grades for the next five years.

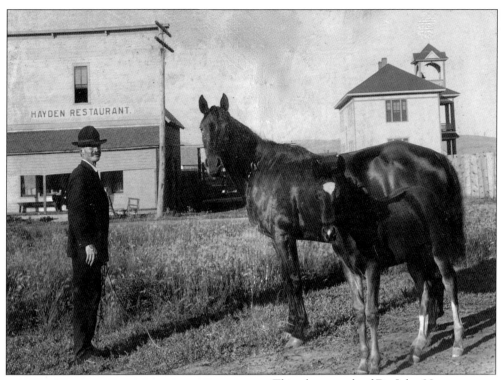

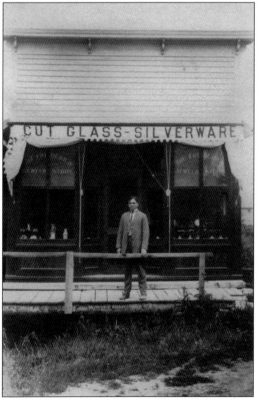

This photograph of Dr. John Vernon Solandt was taken about 1907, when Will Kitchens owned the Hayden Restaurant seen in the background. The restaurant was located on Spruce Street, next to the Dunstan and Stringham Livery Barn. In November 1908, Kitchens moved his restaurant to Walnut Street, and the Mutual Telephone Company moved into the vacated restaurant building. The first telephone operators were Martha Reynolds and her daughter, Minnie.

Adolph Friederich came to Hayden in 1908. A year later, Louis Emrich completed an addition to his barbershop on Walnut Street for the Friederich Jewelry Store and Optical Parlor. During World War I, Friederich served as an optical specialist for the U.S. troops stationed in Vladivostok, Russia. He married Frances Sicher in 1923.

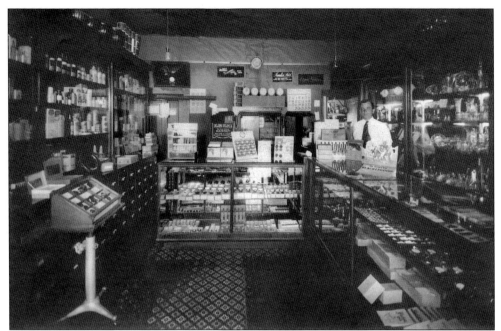

Around 1916, Adolph Friederich added a drugstore to his business. In addition to patent medicines, he also sold veterinary supplies, house paint, and insurance. He developed film and repaired cameras. When Hayden Drug relocated in 1923, Friederich leased the building and moved his business to the other side of Walnut Street. In 1929, Jenny Brock opened a dress shop in the former jewelry store.

The West Hayden Townsite Company originated with David Moffat, who was aware that a developing town site would attract investors for the planned railroad called the Moffat Road. John Cary, Robert Cary, and James Peabody incorporated the town site company on July 23, 1908. This added 10 north-south streets to the existing town, and extended from Poplar Street to the western end of the town's present-day trailer court.

The West Hayden Townsite Co

MIDWAY TERMINAL DIVISION "THE MOFFAT ROAD"

Located on Bear River, Routt County

COLORADO

JOHN S. CARY—Owners and Incorporators—ROBERT J. CARY

J. H. PEABODY, Ex. Gov. of Colo., and F. D. BALDWIN, U. S. A. Retired

Have been made sole agents and offices opened in Room 11, Equitable Building Denver, where plats are on exhibiton and all information furnished concerning this wonderfully rich and rapidly developing portion of the State. Lots are selling fast, selections already having been made for one Hotel, two Banks, one Public Hall, four General Stores, one Drug Store, One Odd Fellows Lodge Building, one Grain Elevator, besides the immense Railroad Buildings necessary for terminal accommodations.

We cordially invite you to call at our offices and "GET ACQUAINTED."

J. H. PEABODY, F. D. BALDWIN,

Exclusive Agents.

R. E. NORVELL, Local Agent.

No. 13 Walnut Street, Opposite Postoffice, **Hayden, Colo**

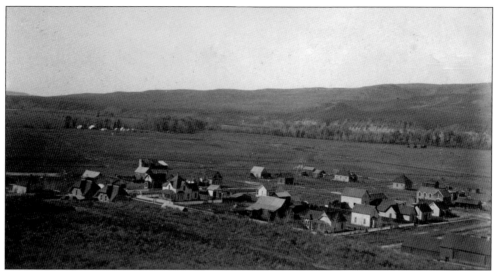

This 1913 view shows west Hayden before the arrival of the railroad that November. The two houses peeping over the brow of the hill (left) were constructed of concrete blocks manufactured by the Hayden Concrete Company. The many-gabled structure (center left) is the Hayden Inn on Poplar Street. The West Hayden Townsite began at Poplar Street and extended 10 blocks west (top of picture).

John and Robert Cary were already successful businessmen when they joined their brother, Samuel, on his ranch west of Hayden in 1898. They began buying neighboring ranches and eventually owned most of the land along the river between Hayden and the present Moffat County line. That first summer, 30 carpenters built three two-story houses, barns, bunkhouses, a blacksmith shop, corrals, and a mile-long cattle shed.

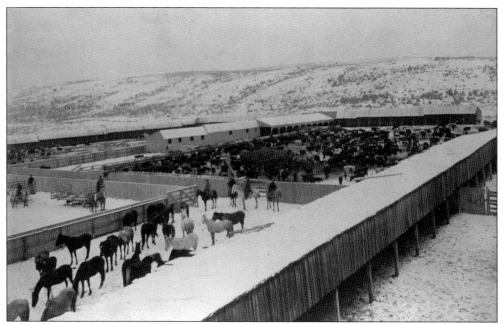

The Cary Ranch, one of the largest cattle operations in Colorado, was the headquarters of the Yampa Livestock and Land Company. The Carys mortgaged their Yampa Valley holdings to cover their investment in the promising West Hayden Townsite Company. When the bottom dropped out of the cattle market after World War I, the Carys were unable to make the mortgage payments. The ranch was foreclosed upon around 1925.

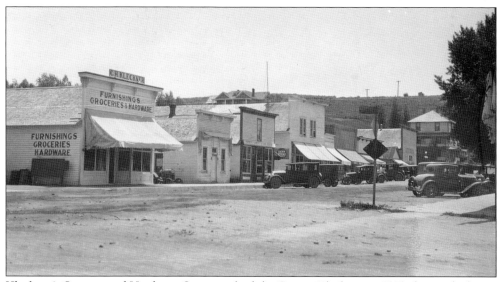

Kleckner's Grocery and Hardware Store was built by George Kleckner in 1909, during the boom created by the West Hayden Townsite. The townsite company's office was located in the store until it moved into new quarters in the west part of town. Kleckner went out of business during World War II; the building later housed a liquor store, which remained in business until 2006.

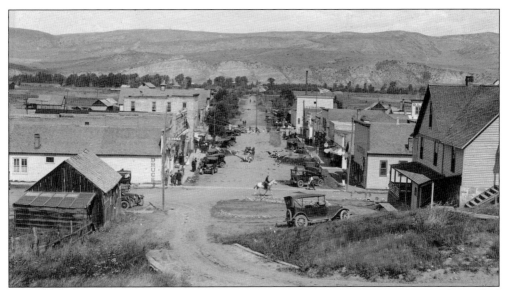

Hayden was a bustling town when this photograph was taken in the summer of 1919. The Oxford Hotel (right) sat at the top of Walnut Street, above Joe Cuber's Auditorium. The Auditorium originally was Parks Hall, built by Alva Parks in 1909–1910. At first, the hall hosted theatrical troupes, but by 1910 it was also used for roller skating and dances. The area's first silent movies were shown here in 1914.

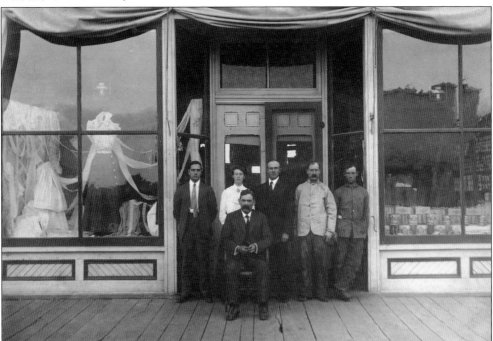

Hayden still had wooden sidewalks in 1909 when Alonzo P. Wood (seated) was the local manager of J. W. Hugus and Company. This company was a mercantile chain that operated throughout rural parts of Colorado and Wyoming. From left to right, Jesse Smith, Ethel Wood, James Monson, Bill Schaefermeyer, and Ira Smith stand in the entrance of the Hugus mercantile. Ethel Wood married James Monson in 1910.

34

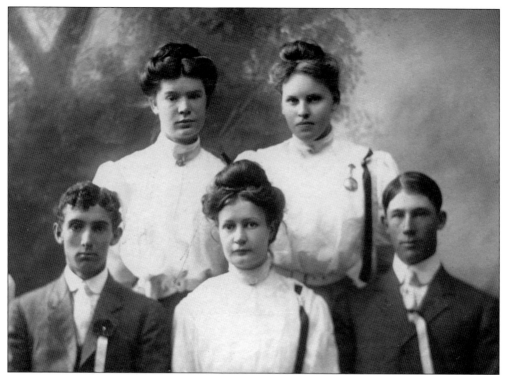

Hayden's first high school commencement was held May 24, 1909, at the Hayden Congregational Church, and an admission of 25¢ was charged. Wolcott Hooker, Gladys Blake (back left), Ethel Wood, and Marabelle Shelton (back right) were the graduates. Class colors were blue and white, and school colors were violet and white. In the front row of this 1909 photograph are (from left to right) Harry Wood, Paroda Fulton, and Stanley Brock.

Ethel Wood, a member of the Hayden High School class of 1909, was the only daughter of Alonzo Wood, the manager of the Hugus store in Hayden. In August 1910, she married James Monson, an employee at the store. Ethel Monson passed away in January 1919, a victim of the influenza epidemic after World War I.

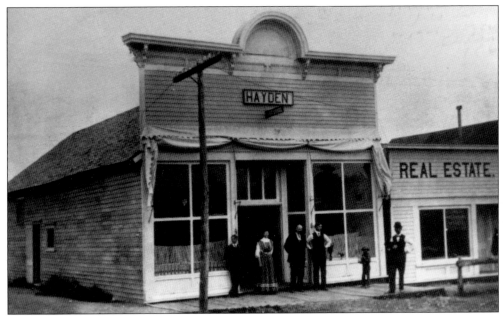

The building in this 1909 photograph was a drugstore owned by Dr. Downs. His son, Fred, was the pharmacist. In January 1909, Fred Downs became Hayden's postmaster and the post office was located in his father's drugstore. A year later, Clayton Whiteman (fourth from left) became the first Hayden postmaster appointed by a U.S. president. Clayton bought the realty building next door and moved the post office into it.

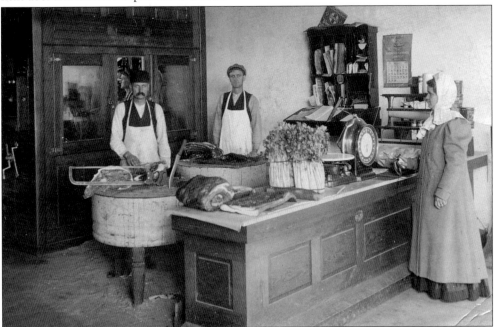

A woman negotiates a purchase with the butchers at a Hayden market in November 1909. The man with the drooping mustache has been tentatively identified as Dave Sellers, who owned a market in Hayden in the early years. Though Hayden was a small town, there were usually two or more grocery stores in business at any one time.

Three

GATHERING STEAM
THE "TEEN" YEARS

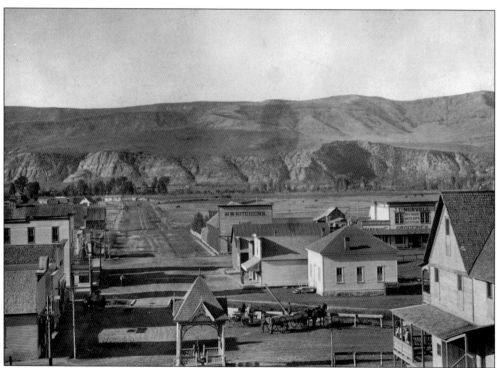

The square building on the east side (right) of Walnut Street was a mission hall built by William Walker in 1903. In 1910, it became a pool hall run by Roy Buzick. One evening, Buzick and two friends, desiring something stronger than soda pop, consumed a great quantity of hair tonic that contained lead and other toxic ingredients. Forty-eight hours later, the three men were dead. (Courtesy of Judy Poteet.)

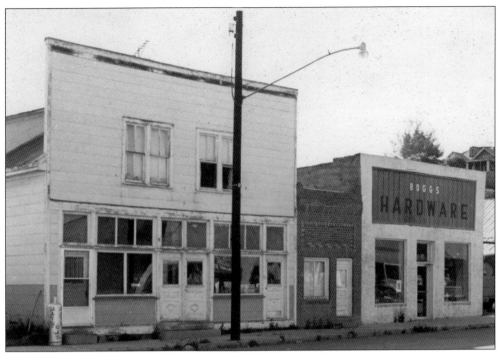

A. O. Fisher and George Honnold bought Roy Buzick's pool hall in the spring of 1911, after Buzick's death from consuming hair tonic. They remodeled it into a two-story structure extending to the street. A pool hall (left), which sold cigars and soft drinks, was on the first floor and sleeping rooms were upstairs. The pool hall closed around 1964, and since then, numerous business ventures have occupied the building.

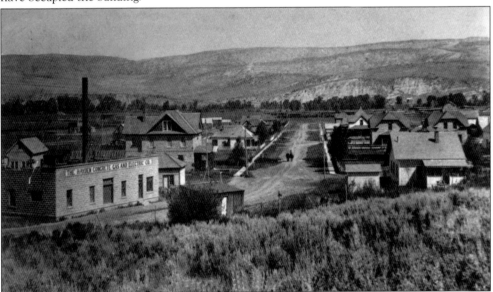

David Flitner and J. E. Miles started the Hayden Concrete Company (left foreground) in May 1909. Because the cement block business did not do well, the plant began producing electric power for the town in 1910. Peter Hofstetter purchased an adjoining lot and used the cement blocks in the construction of the Hayden Rooming House, seen behind the power plant in this photograph.

Gus Rosenberg, a carpenter, and Tom Prevo, a stonemason, did most of the construction of the Hayden Rooming House seen in this photograph. Catherine Hofstetter and her daughter, Zella, managed the boarding house until 1915, when it was sold to John Kitchens. By that time, it had become known as the Hayden Inn. The Hayden Inn was placed on the National Register of Historic Places in 1999. (Courtesy of Bain and Christine White.)

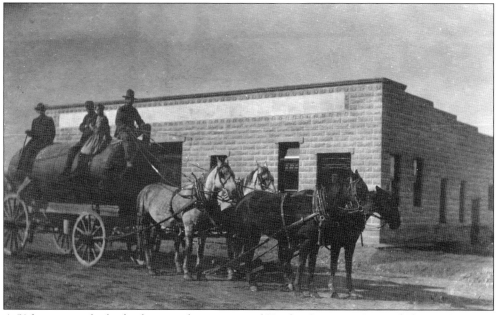

A 50-horsepower boiler for the recently incorporated Hayden Concrete, Gas, and Electric Company arrived in 1910. Peter and Melvin Hofstetter bought the electric plant in 1916 and began milling Flavo Flour two years later. Colorado Utilities bought the property in 1928, and began supplying electric power to the valley. The flour mill burned to the ground on June 20, 1929.

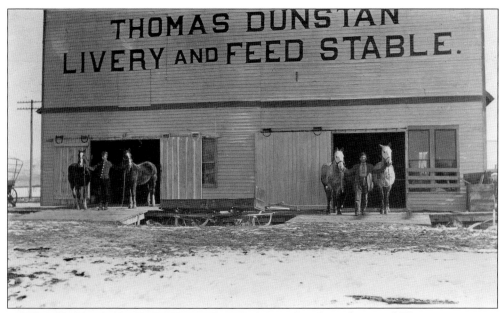

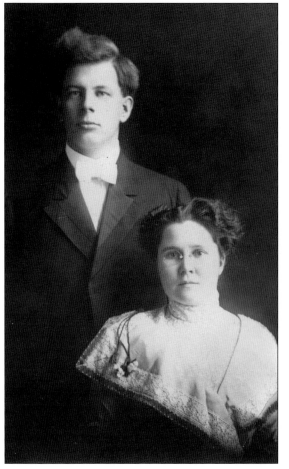

Jess Stringham and Thomas Dunstan opened a new livery barn across the street from the Hayden Congregational Church in March 1909. A year later, the partnership was dissolved, and Dunstan bought Stringham's interest. The building was torn down in 1932, when Elmer Birkett built a tourist court on the site. This photograph of Lee Barnes (left) and Harry Gorham was taken in 1912, shortly after Dunstan sold the livery business.

Young Harley Gill was not a minister when he gave a speech on prohibition at Parks Hall in November 1910, but shortly thereafter, he began filling the pulpit at the Hayden Congregational Church. In 1911, after receiving a license to preach for one year, he was called to serve the church as pastor. Harley married Pearl Jones in January 1912. He resigned the pulpit in 1913 to attend college. (Courtesy of Hayden Congregational Church.)

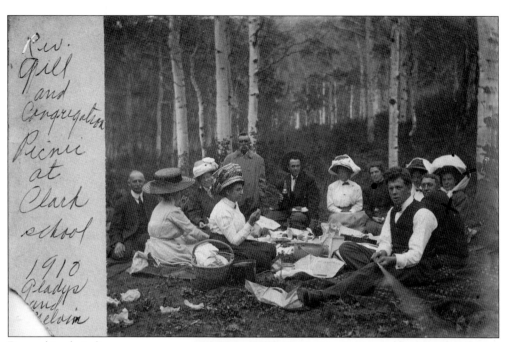

Rev. Gill and Congregation Picnic at Clark school 1910 Gladys and Melvin

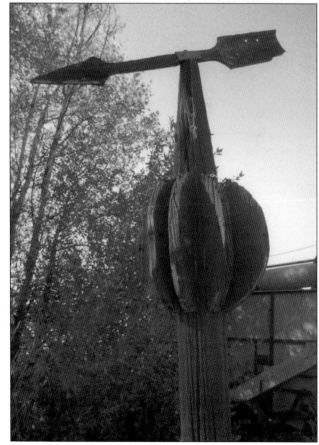

Dressed in their finest, a group of Hayden friends enjoys a church picnic near Clark, Colorado, in 1910. Harley Gill, seated at right, took the photograph—using a string to trip the camera's shutter. Seated directly behind him are Melvin Hofstetter and Gladys Blake, who married in 1912. The man in the overcoat, at the rear, is Billy Pritchard, who carved the wooden weathervane for the original spire on the Congregational church.

William "Billy" Pritchard was born in Wales and came to the United States when he was 26. He settled in Morgan Bottom, north of Hayden, around 1883, and became a successful cattle rancher. He was a charter member of the Congregational church in Hayden and made this wooden weathervane for the church steeple, which was used from 1903 until 1976. The vane is now on display at the Hayden Heritage Center.

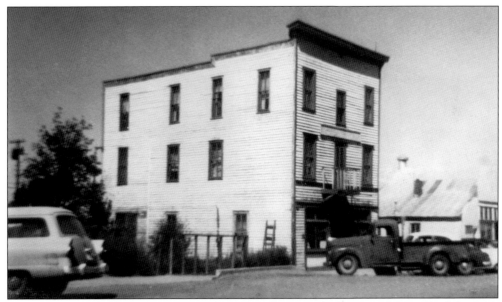

Erasmus Darwin Smith built the Central Hotel in the 1890s for his sister, Mattie Ford. In 1900, her son-in-law, Charles Mason, bought it. The last owner was Nick Evans, who bought it in 1945. By that time, the building was rather worn, and most of the tenants were miners. The 76-year-old hotel was torn down in 1964.

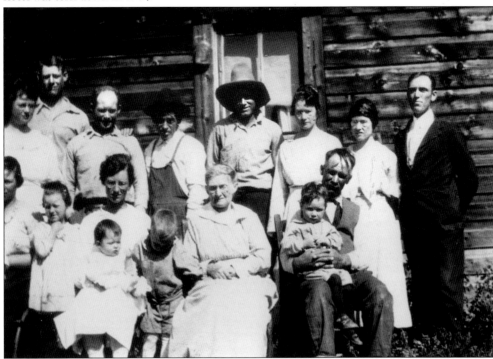

Erasmus Darwin Smith sits next to his wife, Hannah, in this 1920s photograph of a Smith family reunion. The Smiths came to Routt County shortly after their marriage in 1889, and their sawmill near Pilot Knob, north of Hayden, was the first in the area. Mary (second from right) is standing next to her twin, Vada. The Smith twins were the only members of Hayden High School's class of 1915.

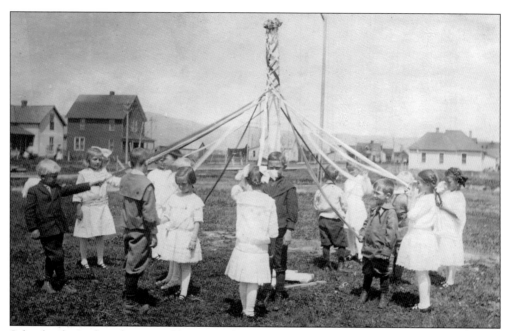

School girls in white dresses and boys in jackets perform a Maypole Dance in front of the Edison School (not visible in photo) in 1912. John Covert (the boy in the sailor suit) and his partner, Ayliffe Jones, wait for the dance to pass over their heads. Two years later, first grade students performed a similar dance for their mothers. (Courtesy of David Joe Zehner.)

Hayden got its first lawyer in 1912, when Ferry Carpenter opened a law practice in a former one-lane bowling alley next to the Yampa Valley Bank. At the time, Ferry was "proving up" on a homestead claim 10 miles north of town, and rode to work on horseback or (in good weather) on a bicycle. (Courtesy of the Fulton Family.)

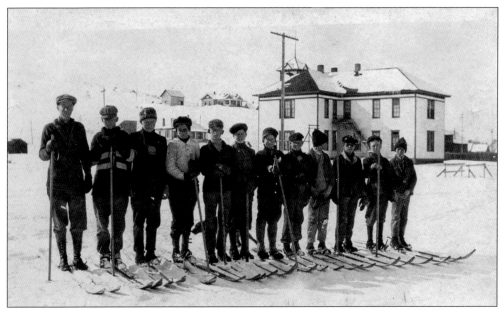

In 1913, Ferry Carpenter (left) posed with this group of boys before a cross-country ski outing. Clifford Mason (third from right) was later a barber in Mount Harris and in Hayden. In 1919, Carpenter organized the Boy Rangers for boys too young to participate in the Boy Scouts program. Seen in the background is the school that most of the boys in the photograph attended.

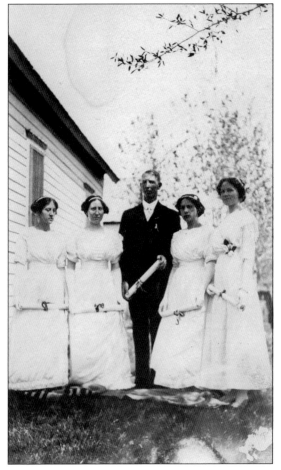

The Hayden High School class of 1913 was the largest in the school's history up to that time. The graduates, from left to right, were Ione Honnold Brock, Ethel Wadge Giboney, Earl Erwin, Irene Honnold Smith (Ione's twin), and Myrtle Horner Harmon. After World War I, Earl delivered groceries for the Hayden Mercantile and bought the business in 1944.

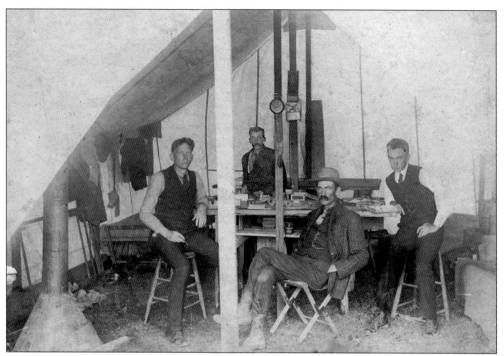

Plans for the Moffat Road were firmly in place long before the first train's arrival in Hayden in 1913. J. J. Argo led a crew of men to survey the rail lines prior to the tracks being laid. Argo is seen here (front right) with the survey crew in their work tent just outside of Hayden. (Courtesy of Museum of Northwest Colorado.)

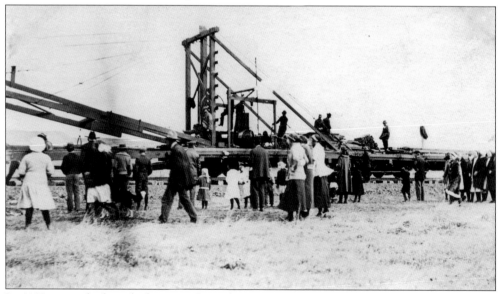

In 1913, crews laid tracks between Steamboat Springs and Hayden. As the railroad inched closer to Hayden in October 1913, curious residents thronged to watch the tracklayers at work. Enthusiastic local residents decided to celebrate the arrival of the railroad on Friday and Saturday, October 24 and 25. Festivities included a barbeque, a grand ball, free moving-picture shows, and a baseball game or two.

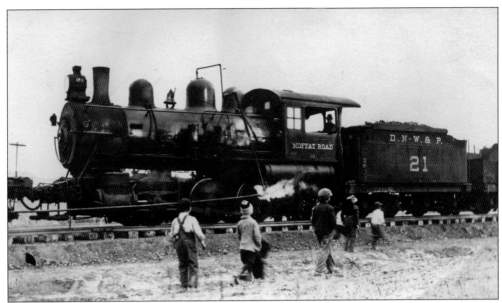

The Moffat Road was reorganized as the Denver and Salt Lake Railroad in January 1913. However, the engine on the first train to Hayden still bore the Moffat Road name, and "Denver, Northwestern and Pacific" was on the coal tender behind it. Most, if not all, of the children in this photograph had never seen a train before.

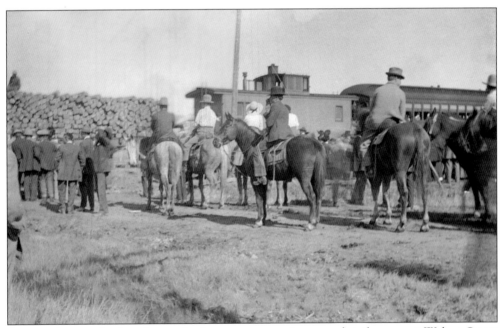

Because the town had no depot, the first passenger train stopped at the present Walnut Street crossing. The men on horseback, from left to right, are Emory Clark, Bruce Dawson, Tex McDowell, Bill Shary, and Guy Bergman. This historic event finally linked Hayden by rail to the outside world, but service was never dependable because the rails ran over 11,600 foot Rollins Pass until the Moffat Tunnel was completed in 1928.

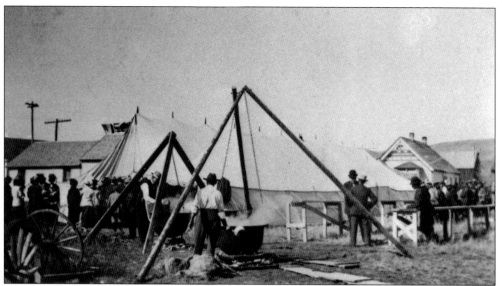

A free barbeque, prepared by Dick Caraway and many willing hands, was served both days on a vacant lot near the office of the *Routt County Republican*. The meat was prepared the night before each barbeque, and in all, two beeves, four muttons, and one elk were served to the crowd of about 1,200.

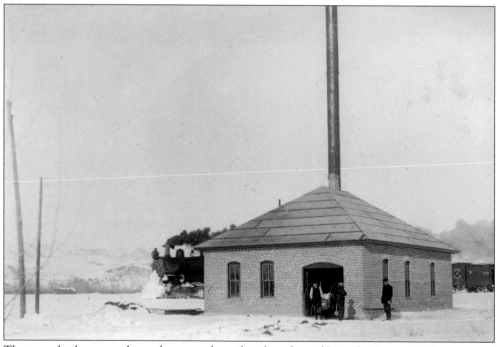

The town built a pump house between the railroad tracks and Lincoln Avenue in the winter of 1913–1914. Water from the Yampa River was to be pumped to a reservoir on Walker (Hospital) Hill, and the first freight train into Hayden brought the pump and two boilers. When the system was tested, the pump station kept the water pressure at 125 pounds for two hours.

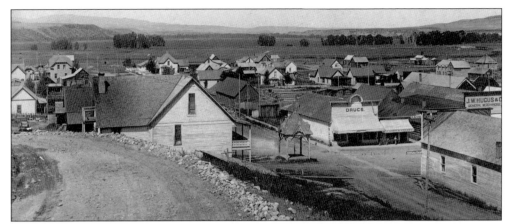

By 1914, the town of Hayden was looking well settled, with a bustling business district. This photograph shows the town as seen from the hill to the southeast. It gives a view of the south end of the Walnut Street shops, which included a candy and cigar store, an ice cream parlor, a drugstore, and a gasoline station.

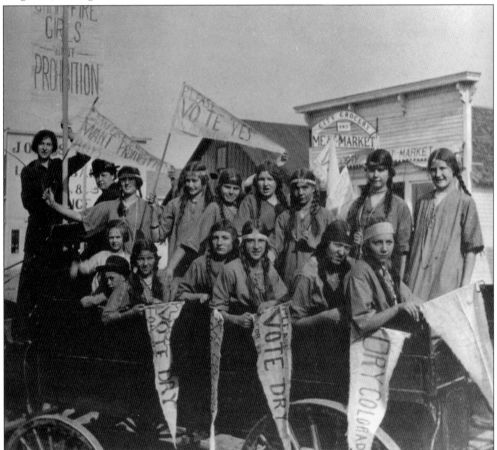

The first Camp Fire Girls troop was started in Hayden in 1913. As the name of their troop, the girls chose "Chipeta"—the name of the wife of the Ute leader, Ouray. This group was active until 1917 or 1918, and for more than 50 years, they kept in touch through a round-robin letter.

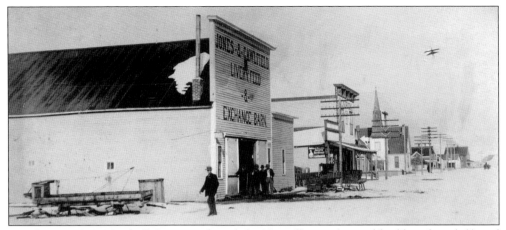

In February 1913, Marshall Starr purchased the Norvell store (second building from left) and moved to Hayden from the county seat at Hahns Peak. Starr, who had served as Routt County clerk from 1908 to 1912, operated the Starr Mercantile until 1918, when he was commissioned postmaster at Hayden. Because he had been appointed by Democrat Woodrow Wilson, he was replaced by Byron Shelton when Republican Warren Harding was elected in 1921.

Elkhead teacher Myrtle Horner (right) and the Shorty Hugenin family posed for this light-hearted photograph c. 1913. From left to right, Stella Huguenin holds the donkey's head while her children, Marie and Flora, pose with Horner. Shorty (the man on the ground) and his family were living on a homestead at the time, and Myrtle Horner was teaching the Bull Pen School. The Huguenins later moved into Hayden and owned a restaurant.

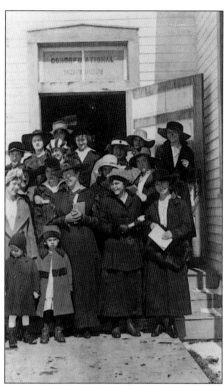

As a result of a break that occurred between the members of the original Ladies Aid Society, Hayden had two Ladies Aid Societies for several years. Both groups supported the Hayden Congregational Church, the only church in town. In 1914, they put aside their differences and merged to form the Women's Association.

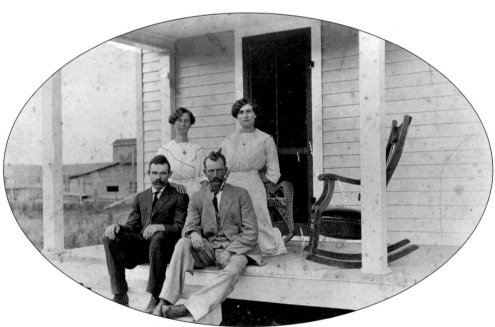

Henry Sellers (right, front) and Anna May Caffee (right, back) were married April 11, 1914. Until the newlyweds moved to their home on Willow Creek a month later, they stayed with relatives in Hayden. The other couple pictured here is Henry's sister, Georgia Wagner, and her husband Ernest Wagner. This 1914 photograph was taken at the Wagner home at 589 East Jefferson Avenue.

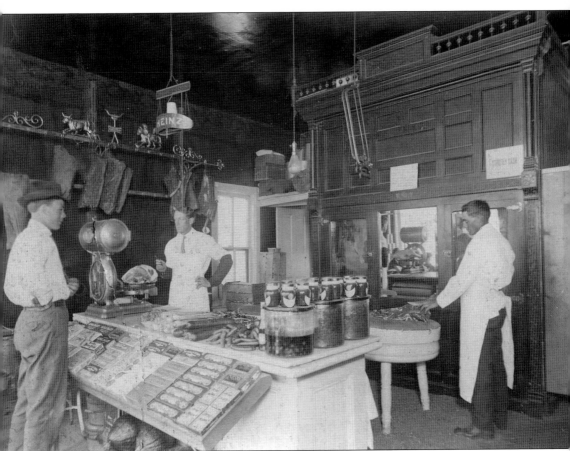

Henry Summer from Sidney, Colorado, formed a partnership with his brother-in-law, George Kleckner, in 1910. Summer operated the meat market in Kleckner's City Grocery and Meat Market on Walnut Street until 1913, when he took over Dave Sellers's meat market directly across the street. In July 1914, Henry Summer went into business for himself and moved just down the block into a building formerly occupied by a Dr. Finney. In this 1914 photograph, Bill Horner (left) is shown with Earl Marvin (center) and Henry Summer. Four years later, Summer hired Gus Rosenberg to replace his building with a concrete structure. At the time, Summer's meat market was the only fireproof building on the east side of the business block. When Henry Summer was elected county commissioner in 1917, he leased the market to Robert Burke, and eventually sold it to him in 1925.

Ben Hofstetter (seated) and Blanche Wadge (right) were Hayden High School's class of 1914. They are shown here with Ben's sister, Zella. Ben was working as a bookkeeper at the Hugus Store in Eagle when he was drafted in October 1917. He was killed on the battlefield in France on October 8, 1918. The American Legion post in Hayden is named in his honor.

The Grand Opening of the new First National Bank of Hayden and J. W. Hugus and Company was held in February 1915. The employees in this 1915 photograph are, from left to right, Alonzo Wood, Lowell Gibbs, Ben Hofstetter, Mae Tiger, Harry Wood, Orville Hughes, Leslie Kimsey, and Ethel Wadge.

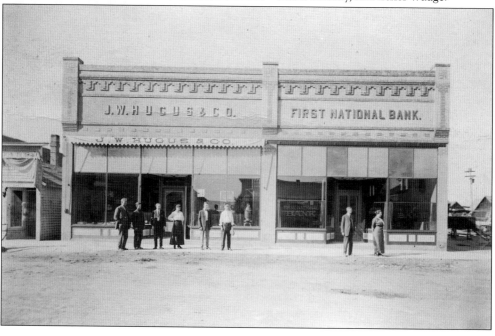

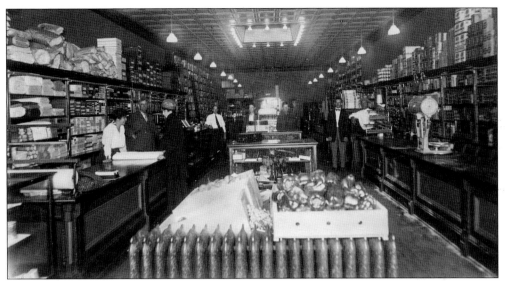

Shopping at the Hugus Store in 1915 was not self-service. Goods were displayed on shelves behind the counter and the store's clerks—referred to as "counter jumpers"—filled the customer's order. In this photograph, Mae Tiger (left) and a customer examine a bolt of cloth, while the manager, Alonzo P. Wood, looks on.

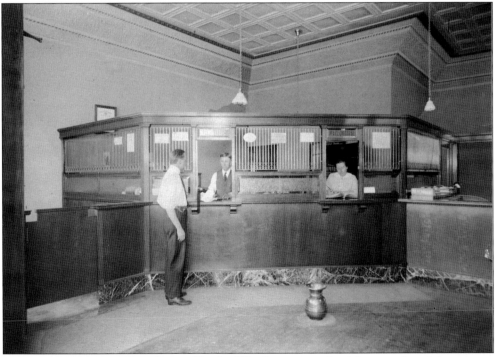

The fixtures in the new First National Bank of Hayden were made of elegant oak with brass upper work and marble settings. Bookkeeper Ben Hofstetter (left) is chatting with the cashier, Leslie Kimsey, and teller Ethel Wadge. When cattle prices dropped in the 1920s, the bank was unable to collect on loans made to cattle ranchers. On June 9, 1926, the bank closed and never reopened.

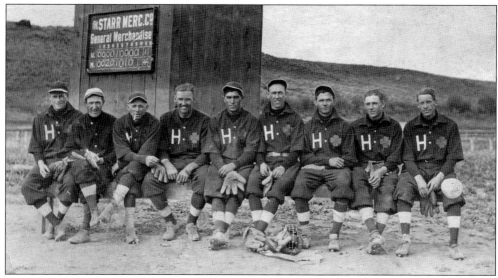

This photograph of Hayden's baseball team was taken at the ball fields at the fairgrounds in Hayden. Shown here from left to right are Quinn Starr, Carl Fink, Enochs Beasley, "Lefty" Flynn, Andy Freyer, Neal Burch, James McLean, Bill Starr, and Earl Marvin. In 1918, two years after this photograph was taken, James McLean lost his life in World War I. "Lefty" Flynn became a stunt man and movie actor.

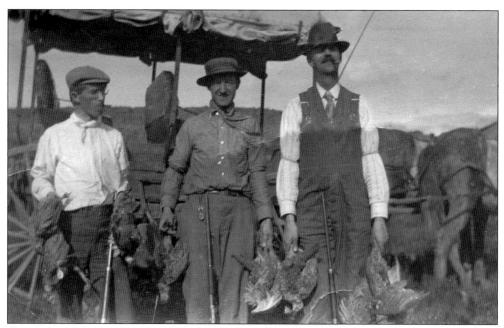

Shown from left to right, Ollie Hill, Carl Fink, and Mac Burch return from a day spent hunting sage chickens. Hill, who occasionally worked at the Norvell Mercantile store, and Fink, a local barber, spent the winter of 1913–1914 prospecting for gold on Blue Mountain, west of Craig. They returned empty-handed, and Fink resumed his barbering business.

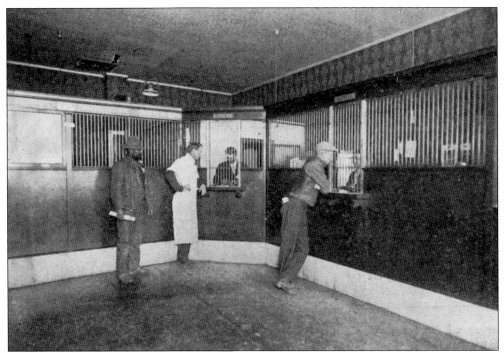

In 1912, the Yampa Valley Bank moved from the Norvell store to a building on Walnut Street that had been George Anderson's hardware store. It took hard pulling by four horses to drag the safe to the new location shown here. The bank closed to observe a moratorium during the Depression and never reopened.

Ezekiel Shelton holds his great-granddaughter, Marian, in this c. 1919 photograph. Marian was the daughter of Sam and Del Shelton, and the granddaughter of Byron and Anna Shelton. After Sam put in the first bathroom in east Hayden, Marian and her brother sold baths to the neighbors' children while all of the mothers were at Women's Club. One day Del came home early from the meeting, and the enterprise came to an end. (Courtesy of AnnaDel Paxton.)

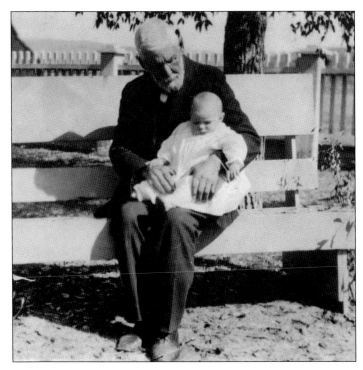

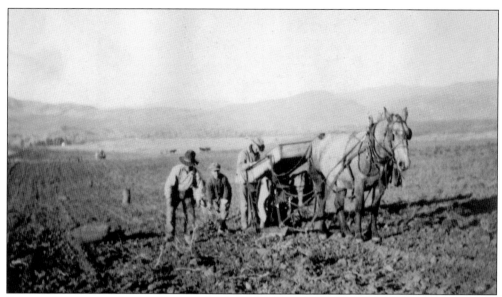

Potatoes became a cash crop after a carload of seed potatoes was shipped into Hayden by rail in 1914. McClures, Burbanks, and Peachblows were particularly suited to the dry farming in the Hayden area. The preacher, the teacher, the lawyer, and anyone else who could be persuaded, showed up to harvest the crop. This field was located up in the Elkhead area, north of Hayden.

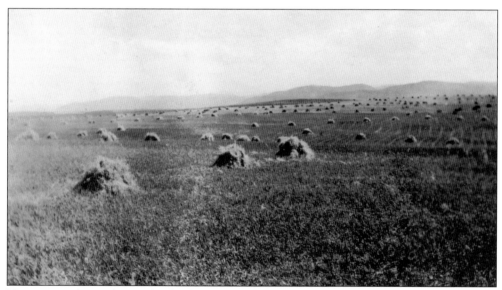

Hay was another cash crop for the farmers in the Yampa Valley. Early farmers harvested with a scythe, but with the advent of horse-drawn mowing machines and hay rakes, more hay could be raised. The hay was piled by hand into two-foot stacks and left in the field to dry.

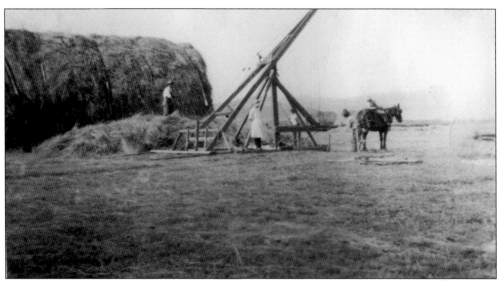

Stackers were usually homemade, as seen in this 1915 photograph. The dry hay was loaded onto a wooden loading fork, which ascended as the horse moved forward. As it raised, the hay rotated over the haystack, and men on top would arrange the hay. If the stack was arranged correctly, it would shed water so the hay could cure without becoming moldy.

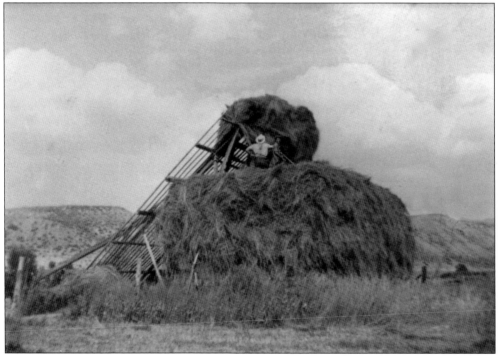

The Mormon stacker shown here was more sophisticated, but worked on the same principle—and was just as dangerous. When the hay was released from the loading fork, it came down fast, and the men on top could get caught in the ropes. Haying crews also had to watch for rattlesnakes hiding in the hay.

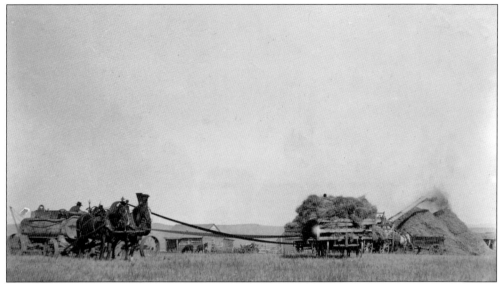

Threshing grain at the George Pearson place near Hayden in 1913 appeared to be an orderly process. The steam engine (left) that drove the threshing machine (right), was located a safe distance from the wagons and stacks to prevent sparks from igniting the chaff. Two years earlier, Pearson's grain fields yielded over 3,000 bushels of oats and wheat, averaging 30 bushels per acre. Grain raised in the area was usually milled locally.

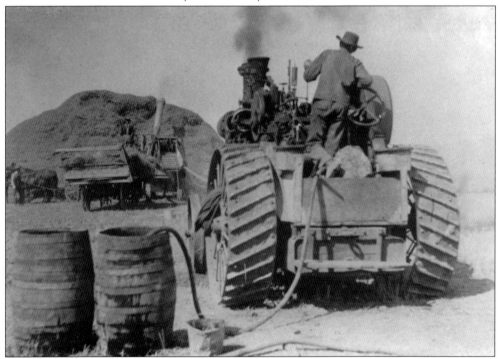

This 1913 photograph shows the steam engine operating at George Pearson's place. The long drive-belt strung from the tractor to the thresher turned the gears for the threshing machine. Steam-driven threshers became widely used after the mid-1800s, and greatly reduced the intensive labor previously needed in raising grain.

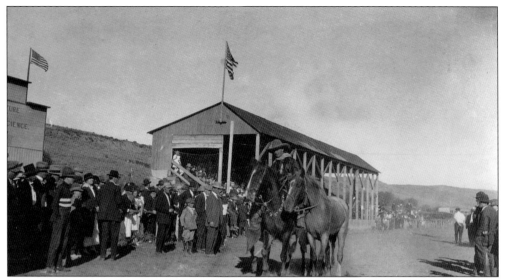

The Railroad Days celebration held in 1913 was so successful that Hayden decided to make it an annual event. The organizers felt that the best way to do this was to hold a fair that promoted agriculture and livestock. The Routt County Fair and Racing Association was organized in November 1913, and the first Routt County Fair was held September 9–11, 1914.

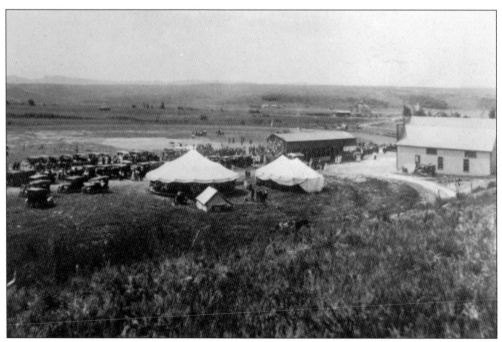

A permanent exhibit building (right) was built in 1915. The dimensions were approximately 35 feet by 60 feet, and a balcony was built so that two floors could be used for exhibits. That year, educational exhibits were added and automobile races were dropped because the track was not suitable. Work on the building began in July, and it was finished in time for the fair.

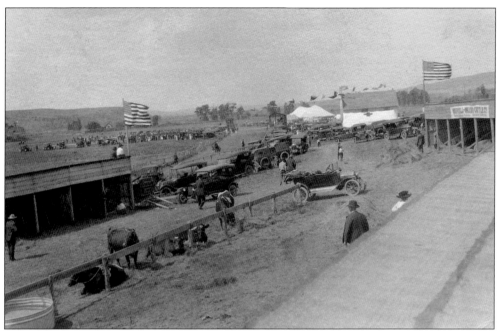

Horse races were a big part of the Routt County Fair. Because seating was limited to a small grandstand (left), spectators were allowed to watch from their automobile or buggy. For a small fee, parking could be reserved in advance. In this photograph, the automobiles are parked around the race track. (Courtesy of the Fulton Family.)

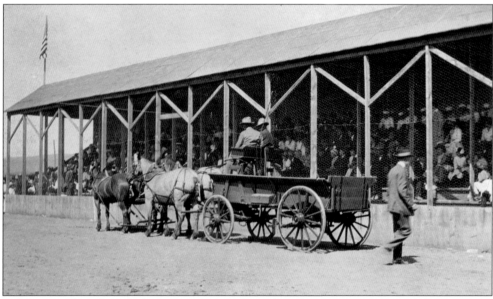

When a grandstand was built in 1914, the upright timbers that supported the roof obstructed the view, so at least half of them were removed in 1916. An addition was built in 1920 that provided 500 more seats, bringing the grandstand's total seating capacity to approximately 1,200. No open betting in front of the grandstands was allowed that year.

Delcina Neilson and Sam Shelton met at a dance at the Elkhead School where she was teaching. They were married on June 2, 1918, by Delcina's brother-in-law, Reverend Samuel Wright of Hayden. When their daughter, Marian, started to school, Sam worked as a custodian at the high school. In 1951, they moved to California and Sam worked as an electrical engineer for Sacramento State College until his death in 1957.

Samuel Forsythe "Sam" Shelton was late for his own wedding. He was to receive his 3rd Degree in Masonry Saturday evening, then go to his parents' home to marry Delcina Neilson. The Masons intentionally dragged out their ceremony, and the wedding finally took place at two o'clock Sunday morning, June 2, 1918. Despite this, Sam and Del were happily married for 39 years.

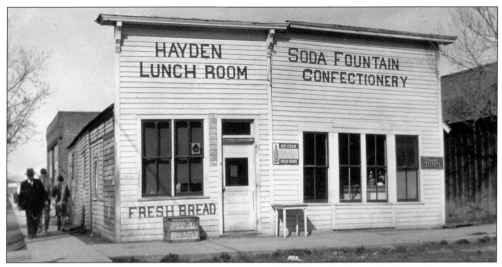

Stella and Shorty Huguenin, who had homesteaded up at Elkhead, bought the old Schaefermeyer building on the corner of Jefferson Avenue and Walnut Street in 1919. They operated the Hayden Lunch Room there until 1926, when they bought the brick building seen here behind the lunch room and moved their business into it. In time, the restaurant became known as Shorty's Café. (Courtesy of the Museum of Northwest Colorado.)

In 1917, at the age of 26, Ruth Bodfish came to teach at the Elkhead School. It was here that she met Edgar Fulton, and the couple was married on June 11, 1919. They made their home on a ranch north of Hayden until 1926, when they moved to town. Ruth Fulton began teaching again, and taught school in Hayden until 1945. A talented musician, she also gave piano lessons.

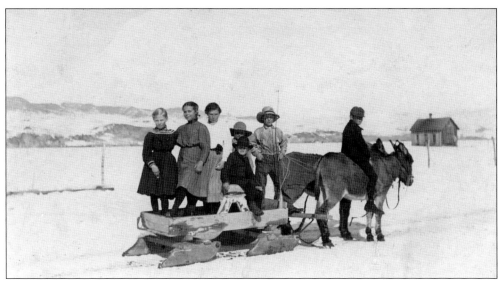

A sled was often the best way to travel in the winter, when the roads were not kept open. The children in this 1919 photograph may be on their way home from school, or just out having fun. Burr Hurd, the son of Mary and Harvey Hurd, was the driver of the donkey-drawn sled.

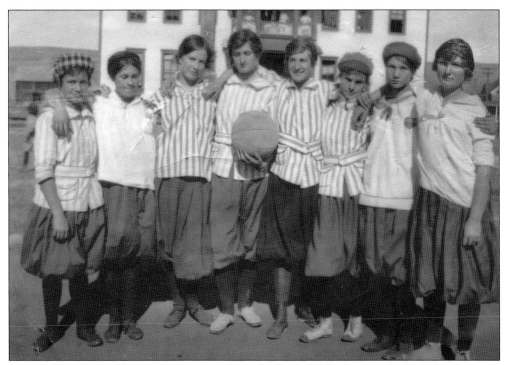

After the Exhibit Building at the fairgrounds was built in 1915, high school basketball games were played there. The girls' team posed for this c. 1917 photograph in front of the school. Shown from left to right are Alma Templeman, Eva Holderness, Gladys Shelton, Bernice Miles, Edith Frink, Lucille Stringham, Margaret Williams, and Lily Mason.

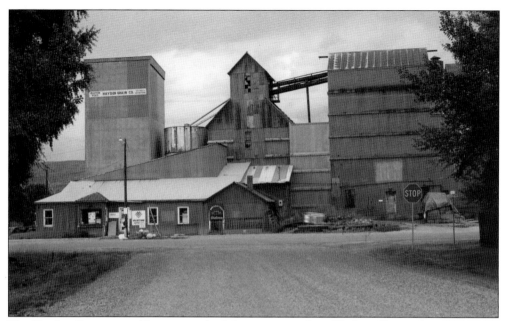

The Hayden Cooperative Elevator was built by a company from Wichita, Kansas, because no one in the Hayden area knew how to construct one. The elevator was completed in December 1917, and James Funk was its first manager. When Charles Deaver purchased it in 1938, he changed the name to Hayden Grain and brought in Lester Grandbouche to manage it. The elevator and feed store are still in business today, and serve as a gathering place for the community.

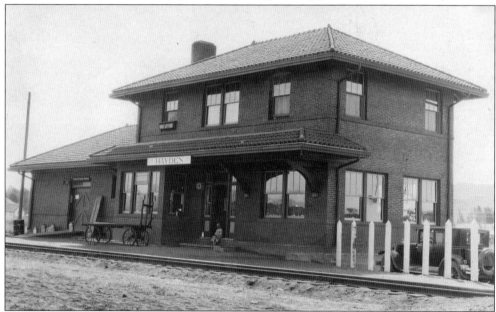

An old Chicago, Burlington, and Quincy boxcar served as living quarters for the railroad's station agent and his family until 1918, when Hayden finally got a depot. Robert McConnell, who was the first station agent in 1913, was the first occupant of the new depot. The building was made of pressed brick, and had a five-room apartment upstairs. The one-story section was a baggage room with a cement floor.

Sumner Hockett bought an interest in Hayden Grain in 1957 and later became the sole owner. In the summer of 1972, much of Hayden Grain was destroyed by fire. When Hockett rebuilt, he added the storage bins seen here. By 1988, there was not much demand for grain storage or feed, and the elevator was closed.

When the country roads were so bad that children could not get to school and mail carriers were delayed, neighbors often took matters into their own hands and repaired the roads themselves. In this *c.* 1915 photograph, Ferry Carpenter (left) and Charles Fulton are grading a road to the Elkhead School.

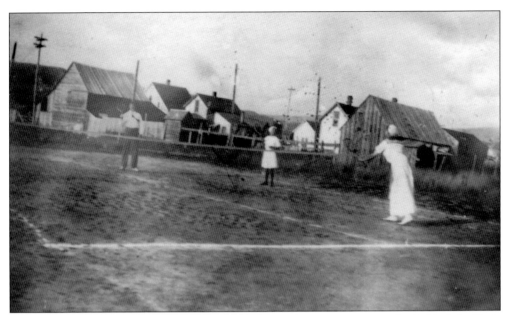

The first tennis court in Hayden was south of Jefferson Avenue on a vacant lot behind the *Routt County Republican* office. A group of young men organized a tennis club in 1911 and laid out the tennis court in west Hayden seen in this 1917 photograph. Six years later, in 1917, another tennis club was formed, and they used the same site.

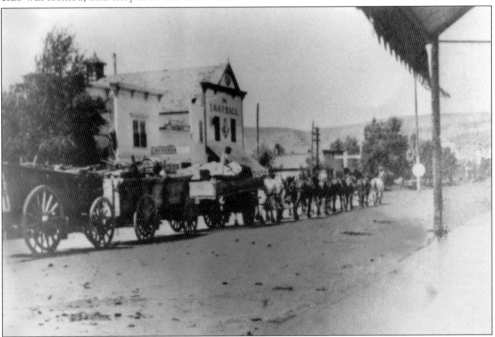

Lerch Covert turns his freighting team around on Walnut Street in 1918. The two-story building seen here with the peaked roof had Furlong's Hardware Store downstairs and a lodge hall upstairs. In 1919, the Odd Fellows Lodge refused to allow Furlong to use part of the second floor for his business. Furlong, who already owned the first floor of the building, settled the matter by buying the second floor.

Four

SETTLING DOWN
THE 1920s

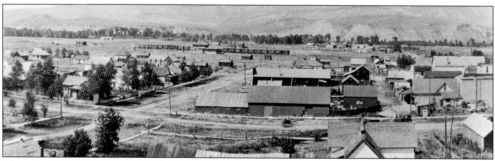

The sale of the Hugus store to the Hayden Mercantile Company in 1919 included their warehouse and lumberyard on Washington Avenue (center foreground). It was torn down in 1945, and the Colorado State Highway Department built an equipment garage on the site. The dark building behind it was a bowling alley built by Dr. Jefferson in 1903.

The young women in the back of this REO Eagle Beak touring car were members of the Ukulele Glee Club. The group performed at chivarees (noisy, mock serenades performed for newly wedded couples) and drove around in the evening, serenading the community. In this c. 1920 photograph, they were part of the festivities at a Routt County Fair.

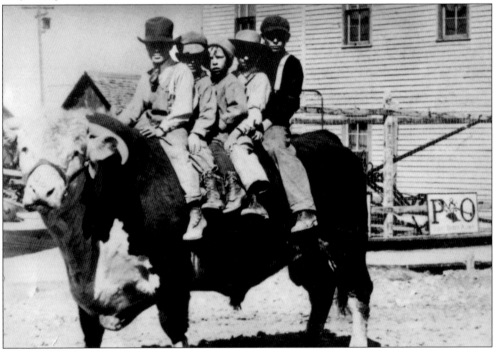

It doesn't take much to entertain rural youth—as this photograph proves. Here, five Hayden boys sit atop one of Ferry Carpenter's prize bulls on downtown Walnut Street. Carpenter was a local lawyer in addition to being a homesteader and rancher, and presumably carried adequate liability coverage in case of a mishap with the boys and the bull. (Courtesy of David Joe Zehner.)

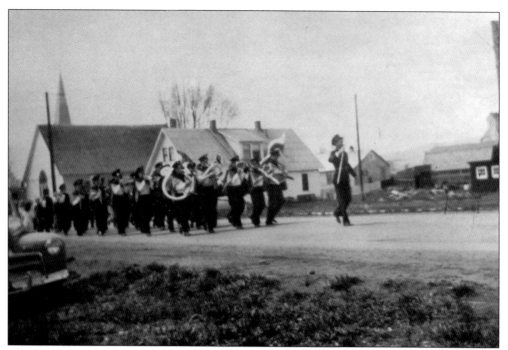

The building behind the Hayden Union High School band is the parsonage for the Hayden Congregational Church. It was built in 1920 by members of the community. Fred Vest was the carpenter, the Hayden Milling and Power Company did the wiring, and Walter Price put in the plumbing. The first minister to occupy the parsonage was Reverend Baer.

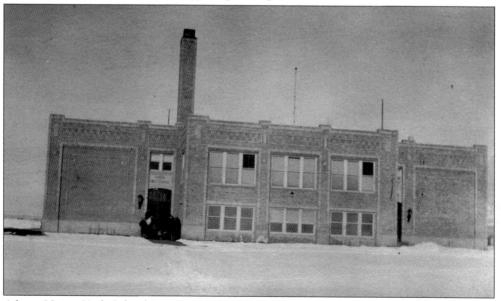

After a Union High School District was formed in 1919, the district voted to build a new high school in west Hayden. Architect Robert Fuller was hired, and construction began in the summer of 1919. Although the building was not finished yet, a senior-class play, *Mary's Millions*, was presented in the new auditorium on May 25, 1921, and 11 seniors received their diplomas there two days later. (Courtesy of Sandy Shimko.)

In 1919, the community began raising money to build a hospital in memory of Dr. John Solandt. The Hugus Company donated land on Walker Hill south of town, and construction began in November when the foundation was poured. Three years and $20,000 later, Solandt Memorial Hospital officially opened for business in July 1923. The stately building still stands today, overlooking the town and serving as a medical clinic and office building.

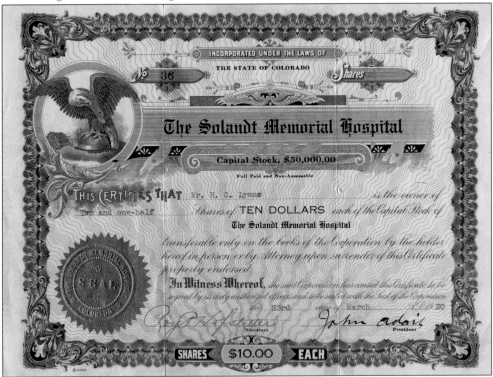

Funds for the construction and maintenance of the hospital were raised by selling shares. For $200, a family or organization from Hayden or Mount Harris could furnish a patient room. A charity ball was held June 14, 1923, to raise more money, and became an annual event known as the Hospital Ball.

When the Solandt Memorial Hospital was built in 1923, it was the only certified and fully modern hospital in the area. The building represented the subscription of 350 stockholders who had faith in the future of such a facility in a rural town of 600 people. Today, the building houses a medical clinic, dentist office, and other services.

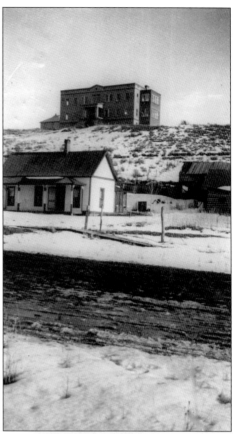

The staff of Solandt Memorial Hospital in this c. 1943 photograph was, from left to right, Amy Gledhill and daughter Karen, Dorothy Springer and daughter Gretchen, Marie Drury, Avis Hooker, and Barbara "Gram" Connelly. Marie Drury and Dorothy Schidler arrived in Hayden in June 1937 to work at the Solandt Hospital. The two took one look at the stark hospital on the hill, and drove on to Craig. Craig wasn't much better, so they returned to Hayden and were talked into staying for two years. Marie was hired as administrator, and Dorothy was a nurse until she married Jimmy Springer in June 1938.

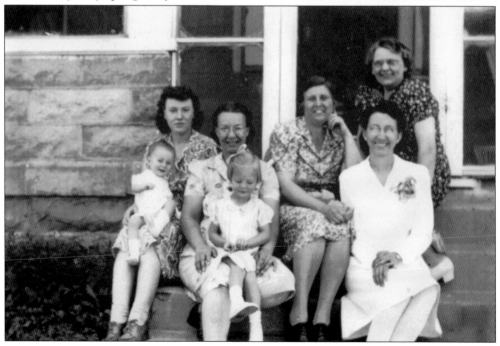

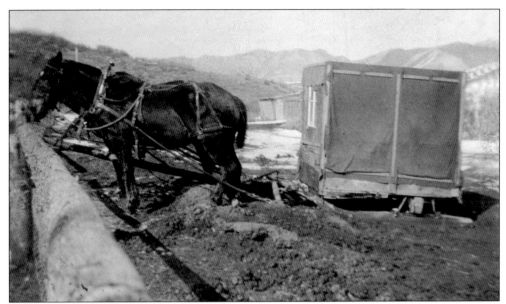

Charles Boyles used this horse-drawn sled from 1923 to 1925 as the mail stage when he carried the mail from Hayden to the Dunkley Post Office, 19 miles south of town. The mail carrier was the community's link to the outside world, bringing not only mail but groceries, medicine, machine parts, baby chicks, an occasional passenger, and the latest news.

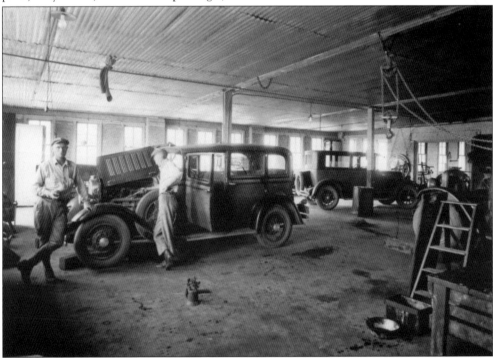

Ray Goree (left) and Bob Hope posed for this photograph in the Hayden Garage owned by Earl Flanagan. Flanagan started the business in 1919 and added a Studebaker dealership in 1924. The garage became the Bear River Valley Co-op in 1940. The building was torn down in 1965 and replaced by the present co-op building.

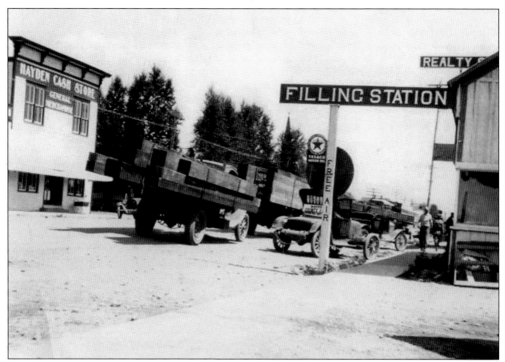

The building at right in this c. 1925 photograph was formerly a warehouse for the Starr Mercantile across the street. In 1923, Hugh Pleasant opened the Bear Valley Motor Company and a Ford dealership in the building. The Starr Mercantile store was sold to Dave Sellers in 1915. Sellers, in turn, sold it to John Birkett, who operated it as the Hayden Cash Store. (Courtesy of the Museum of Northwest Colorado.)

The Giboney Building on Jefferson Avenue extends from Walnut Street (left) to the alley. It is named for George Giboney, who came to Hayden in 1917 to be a bookkeeper for J. W. Hugus and Company. Giboney had the two-story section built in 1927, but it was not until after World War II that the one-story section was completed. (Courtesy of Nadine Leslie.)

An open house for the new Giboney Building was held in April 1926. The first tenants were the Wood Toggery, Marvin and Sherwood's Meat Market, the Fink Barber and Beauty Shop, and the Mountain Bell Telephone office. The second floor had offices for the doctors, a dentist, and a lawyer. In 1974, a leather shop occupied the former telephone office, and Yampa Valley Electric Company (left) had replaced Wood's Toggery.

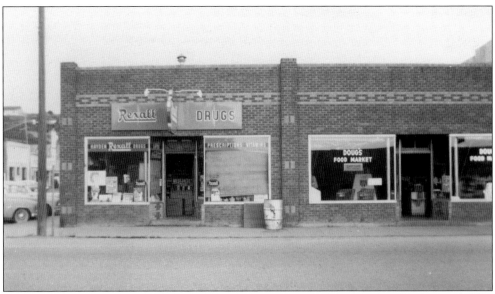

In 1946, George Giboney tore down the old wooden drugstore on the corner and extended his building to Walnut Street. The first occupants were Furlong's Home Furnishings and Hardware, Truman Leslie's Hayden Pharmacy, and the Ace Shoe Shop, owned by Larry Chavis. In this 1958 photograph, the drugstore is on the corner, next to Doug Bennett's Meat Market.

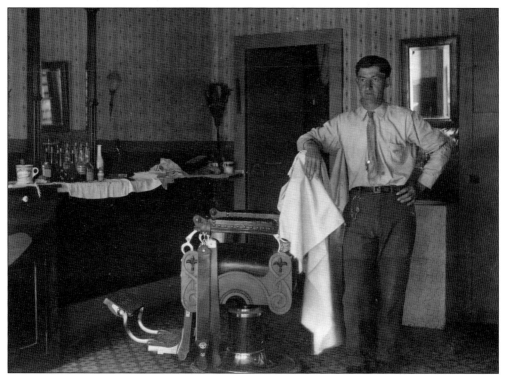

Carl Fink's barbershop was one of the first businesses in the new Giboney Building. Carl started barbering in 1911 in a shop on Walnut Street, and in 1917 he bought the business. He and his wife, Minnie, operated the Fink Barbershop and Beauty Parlor until they retired in 1965.

Adolph Friederich moved his optical parlor and jewelry store into this building on the southwest corner of Walnut Street and Washington Avenue in 1923. Frances Friederich and her son, George, are shown outside the building in 1928. Adolph was a charter member of the Benjamin J. Hofstetter American Legion Post, and Frances was one of the first to join the Hayden Legion Auxiliary.

On July 7, 1924, Friederich opened a soda fountain and advertised that he served ice cream from C. E. Rose's ice cream factory in Hayden. The Friederichs had two sons, William (left) and George. After Adolph's death in 1928, Frances ran the business until 1930, when she sold it to Glenn Kitchens. The store burned to the ground in December 1931.

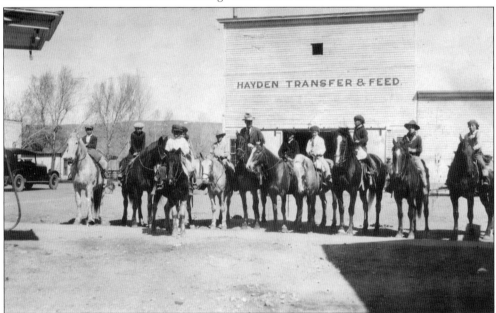

This photograph of Ferry Carpenter (sixth from right) and a group of Boy Scouts was taken in front of the Bear Valley Motor Company about 1925. The garage, which sold gasoline, was located on the southwest corner of Walnut Street and Jefferson Avenue. At the time, Hayden Transfer and Feed (located across the street) was owned by William Kleckner, and was using gasoline-powered trucks instead of horses for hauling goods.

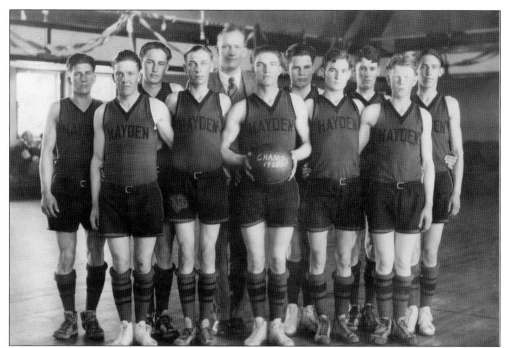

The boys' basketball team from Hayden Union High School won the Yampa Conference title in 1928. From left to right, they are Alton Welch, Leonard Lighthizer, unidentified, Herbert Summer, coach Hap Dotson, Gilbert Evans, Stanley Smith, Frank Hughes, Ben Fulton, "Red" Spooner, and Gilbert Summer. Spectators watched the games from balconies on both sides of the high school gymnasium.

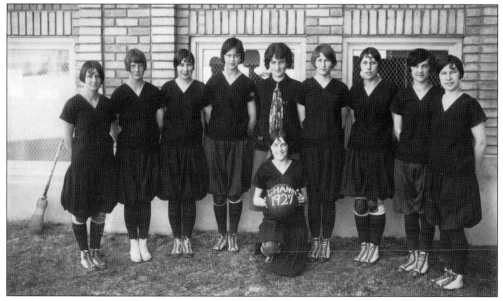

For three years in a row, the girls' high school basketball team won the Yampa Valley Conference title. Shown here in 1927, from left to right, are Fern Kimsey, Carrie Bennett, Roberta Whiteman, Willie Mullins, coach Edna Hamilton, Claudia Corbin, Allie Kleckner, Okla Rice, and Ruth Birkett. Virginia Waterhouse is in the front with the championship ball.

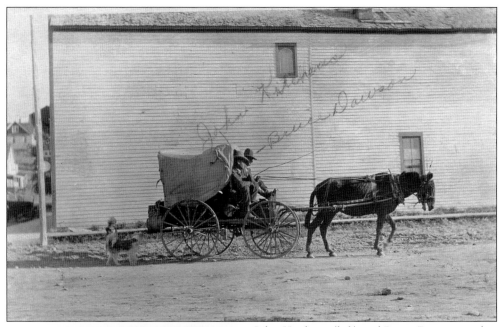

John Kitchens (left) and Bruce Dawson paid a fellow $5 to use his wagon for this photograph. The two-story building sat on the corner of Walnut Street and Jefferson Avenue, and the entrance faced Walnut Street (left). George Giboney, who owned Hayden Drug, bought the building from Edward Furlong in 1923 and moved the drugstore into it. He also leased the second floor to the Masonic Lodge.

Jenny Brock's first experience in the business world was on horseback, taking orders for imported dresses from farm and ranch women who lived out of town. In a few months, she was using an old buggy drawn by a balky horse. Eventually, she bought a Model T, and took her dresses to Mount Harris to sell. In March 1929, after Friederich's Jewelry moved across the street, Jenny moved into the vacated building and operated Brock's Style Shoppe until she retired in 1959.

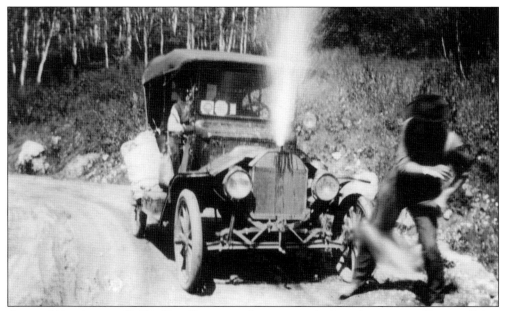

Automobile trips over Rabbit Ears Pass were often a necessity in order to get to Denver. Other times, a road trip was made simply for the adventure and challenge of traveling on rough roads. In this photograph, Alfred Musgrave, the author's grandfather, backs away from the steam of an overheated radiator, which occurred while Musgrave was traveling over the rough pass sometime around 1920.

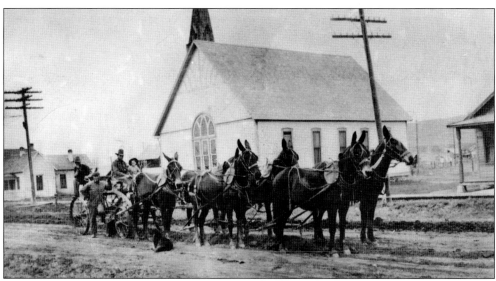

Richard "Tex" McDowell (seated) is shown with his six-mule team in front of the Hayden Congregational Church in this 1920s photograph. For more than 30 years, Tex built roads and bridges in the area, including the river bridge and the Middle Cog road north of Hayden. In 1941, he received nationwide attention in *Ripley's Believe It or Not* after he was bitten by a rattlesnake, and the snake died.

This late-1920s photograph shows Hayden Union High School with some relatively new landscaping in place. The young cottonwood trees, seen in the foreground, grew into the stately giants that grace Jefferson Avenue today. Hayden has been designated an official Tree City of America because of the town's determination to continue to care for and plant trees within town limits. (Courtesy of Museum of Northwest Colorado.)

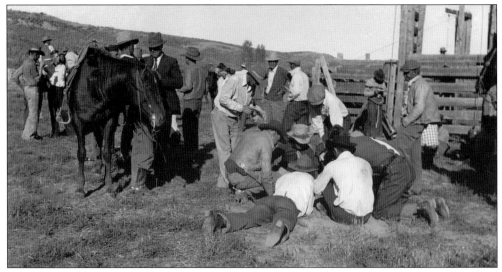

Cowboys pass the time while waiting for the next event at the Routt County Fairgrounds in this c. 1920s photograph. It doesn't take much imagination to figure out that the group on the ground is most likely intent on a game of chance. Not much has changed at the fairgrounds in this rural area, and except for clothing and a few small details, this photograph might have been taken today.

Five

HANGING IN THERE
THE 1930S

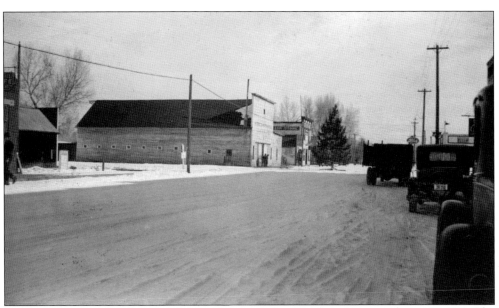

Colorado began issuing license plates with county numbers based on population in 1931. The number assigned to Routt County vehicles was 28, as seen at right. The community Christmas tree, shown here sitting in the intersection of Jefferson Avenue and Walnut Street, was frequently knocked down by passing motorists. A few years after this picture was taken, in 1935, Sam Lighthizer purchased the old Hayden Cash Store building to the right of the livery barn and opened a beer parlor.

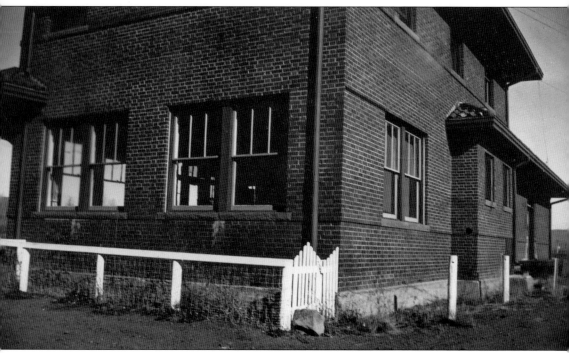

E. F. Collier was the agent at the Hayden train station when this photograph was taken in the 1930s. The Dotsero Cutoff, which linked the Denver and Salt Lake rails with the Rio Grande Railroad, was completed in 1931. In May 1946, passenger service into northwest Colorado was discontinued, but was restored two weeks later by order of the U.S. Defense Department. Later that year, the Rio Grande Railroad merged with the Denver and Salt Lake. By 1960, passenger service was something that everyone wanted, but no one used; when it was irrevocably discontinued in 1968, the Hayden depot was closed. The building became the property of the Town of Hayden in 1970, and the Hayden Heritage Center opened in the old depot on August 9, 1975. The depot was placed on the National Register of Historic Places on October 22, 1992, and on the Historic Routt County Registry on October 5, 1993.

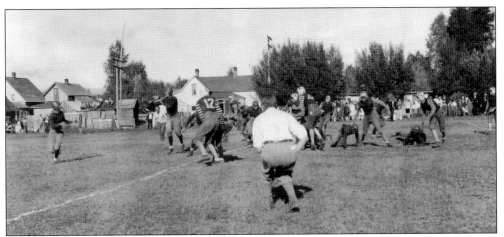

High school football games were usually well attended in rural towns, as seen by the number of spectators in the background of this photograph. Fierce rivalries between all of the Yampa Valley towns sprang up early and continues today. This 1930s photograph shows a football game between the Hayden Union High School and another unidentified team.

In 1932, the Colorado State Highway Department was leasing the building with the awning, which was located on Walnut Street. The old bridge over the Yampa River west of Mount Harris was being replaced, and since this was during the Depression, only local labor was used. Burr Hurd (in light clothes) is shown here with some of the workers. The building, which was located between the Auditorium Theatre and Brock's Style Shoppe, became the Hayden Public Library later that year.

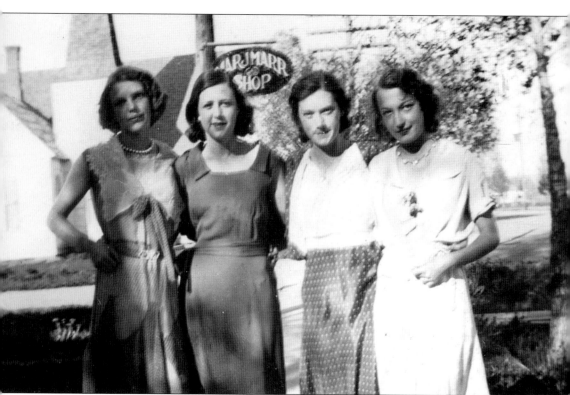

From left to right, Virginia Marr, Sybil Hofstetter, Avis Hooker, and Annabelle Brock are shown in front of the Marj Marr shop in Hayden in 1933. In order to afford schooling for her daughters, Virginia and Betty, Marjorie Harrison Marr began making and selling hats in Hayden in 1923. She had a small shop on Walnut Street before moving it into this house on the corner of Jefferson Avenue and Spruce Street. The shop was in the front, the family lived in back, and Hayden Congregational Church was just across the street. In 1935, she bought a business in Steamboat Springs and operated a dress shop there for a couple of years before selling her inventory to her competitor, Dorothy Wither, who owned Dorothy's Shop. In 1937, she opened the Marj Marr Shop in Craig, and for the next 26 years, she was Craig's most successful businesswoman.

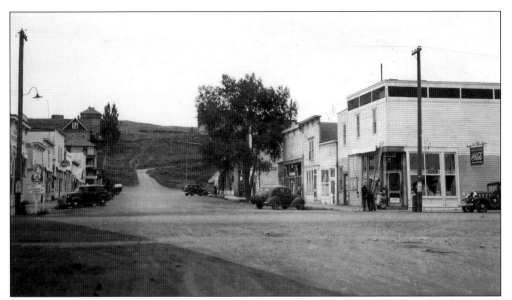

This photograph was taken in 1932, when the entrance to Hayden Drug was moved to the corner. In 1934, Jenny Brock and Dr. Whittaker formed the Hayden Drugstore Corporation, and Lonny Brock managed the business. The partnership later dissolved and the business became Brock's Pharmacy. In 1943, Truman and Velora Leslie moved to Hayden with their two young children from Mount Harris, where Truman had been the pharmacist. They purchased the Brocks' business and operated it as the Hayden Pharmacy.

The brick building at the corner of Jefferson Avenue and Poplar Street is the Hayden Masonic Temple. For symbolic reasons, all Masonic Lodges are situated due east and west, and when this building was constructed in 1934, it was designed that way. It is the home of Hayden Valley Lodge 126 and Hayden Chapter 99, Order of the Eastern Star. On April 18, 2005, the building was listed on the Historic Routt County Registry.

Routt County residents didn't feel the Depression as severely as those in larger metropolitan areas. Food was still available, both homegrown and hunted. The local Home Demonstration Agents worked to help provide work and financial relief to those in need. In this 1933 photograph, Zunker Jacobson stands by a pile of split firewood in Hayden during a relief work project.

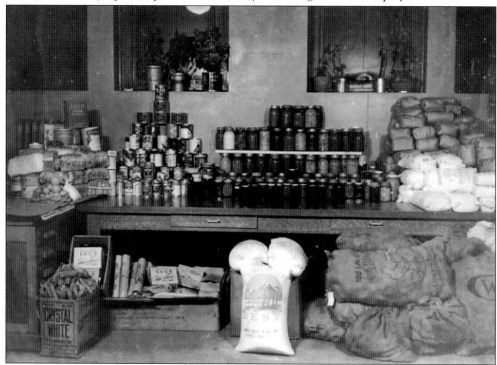

A collection of food products, including homegrown produce and home-canned items, is displayed in this 1933 photograph taken at the local theater, located in the Legion Hall. The Routt County Home Demonstration Agent hosted a movie night where the price of admission was a food item, which would later be distributed to the needy.

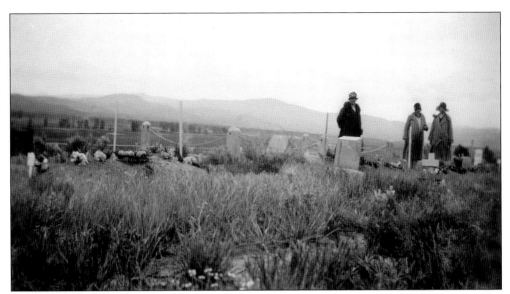

The Hayden Cemetery was just a burying place on a hill southeast of town until April 8, 1937, when the Hayden Cemetery Association was formed. The first directors of the association represented the communities of Hayden, Mount Harris, Bear River, and Tow Creek. Ernest Wagner, a local saddle maker, led the effort to beautify the grounds.

When construction of the Church of Christ began in November 1938, the members planned to build a basement to use for their services until they could complete the building. The next summer, the building was ready for occupancy and the first services were held in the new building in July 1939.

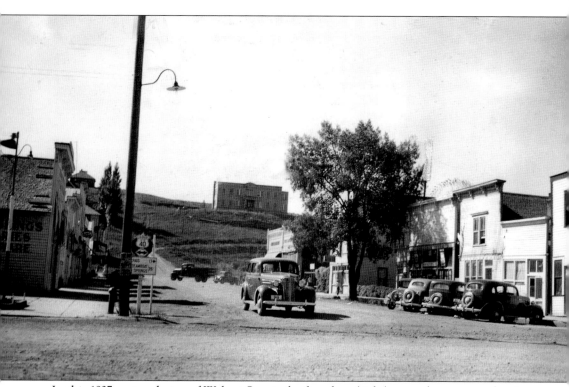

In this 1937 postcard view of Walnut Street, the first door (right) opened to a covered stairway leading to a lodge hall on the second floor of the Brock's Pharmacy building. The Hayden Masonic Lodge met here until 1934, when they built the Masonic Temple on west Jefferson Avenue. The two buildings to the left of the stairway were Frank's Bakery, owned by Weldon Frank. The bakery burned in December 1937, completely destroying the one-story section, and Frank and his family moved to Craig. The building to the left of the bakery was the Crystal Theatre, which had opened in 1936 in the former Yampa Valley Bank building. In 1938, Ernest Wagner, who had added furniture and large appliances to his business, occupied this building. In 1946, George Giboney tore down the former drugstore and bakery buildings and built the present brick structure.

Arnold "Zeke" Zabel is shown in the doorway of the *Routt County Republican* office in this *c.* 1935 photograph. After the newspaper office burned in 1932, the business moved into the brick Stearns garage building on West Jefferson Avenue. Zeke Zabel from Athol, Kansas, took over the management of the *Republican* on June 1, 1935.

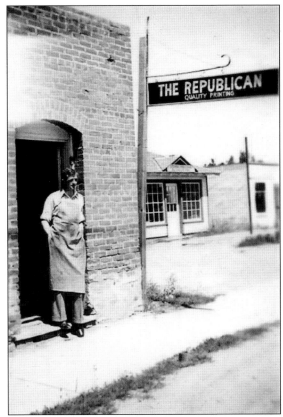

The Stearns building was originally the two-story Parker House built by John Parker. From left to right in this *c.* 1935 photograph of the interior of the *Republican* building are Ray Zabel (Zeke Zabel's nephew), editor Zeke Zabel, and Ray Kiddie. In 1943, Zabel sold the newspaper to the Rev. W. S. Stevenson, minister of the Hayden Congregational Church.

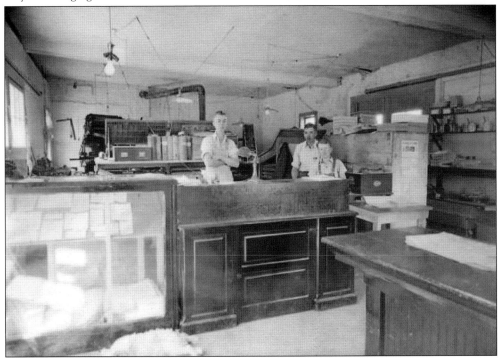

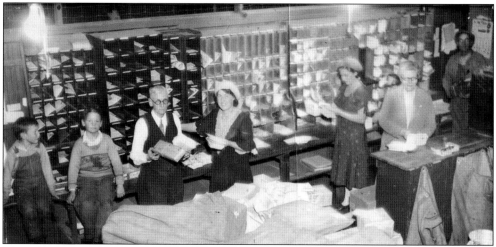

Bryon Shelton (third from left) served as Hayden's postmaster from 1922 to 1934. His predecessor, Marshall Starr, had been appointed by Democratic President Woodrow Wilson, but when Republican Warren Harding was elected in 1921, a new postmaster had to be found. This c. 1930s photograph was taken when the post office was located in the former Bank of Hayden Building on Walnut Street. Shelton's wife, Anna, (second from right) was his clerk.

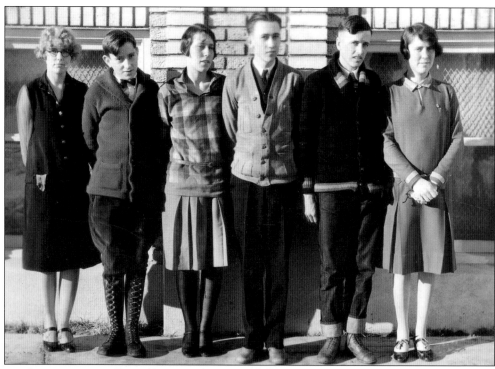

Teachers Mary Biner (left) and Willie Hogsett (right) pose for this photograph with members of the Hayden Union High School debate team. From left to right, the team members are Milton Coverston, Allie Kleckner, George Davis, and Oliver Watts. On July 5, 1930, Mary Biner married Charles Wilkins of the Dawson Ranch just east of Hayden. Charles was in charge of the company store for the Wadge Mine at Mount Harris until 1936.

Six

SMALL TOWN
THE 1940S

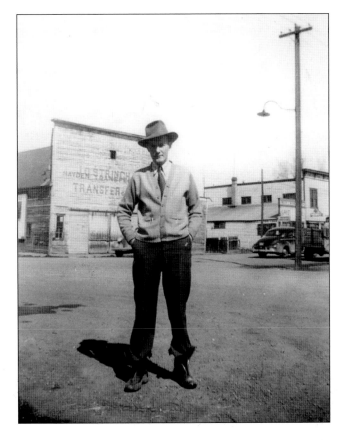

In the 1940s, *Ripley's Believe It or Not* recognized the Hayden livery barn as the only livery barn to be located on a main street in the country. On October 11, 1946, the livery barn was gutted by a fire thought to have been caused by a defective flue. The fated barn stands in the background of this 1944 photograph of Truman Leslie, the new owner of the Hayden Pharmacy.

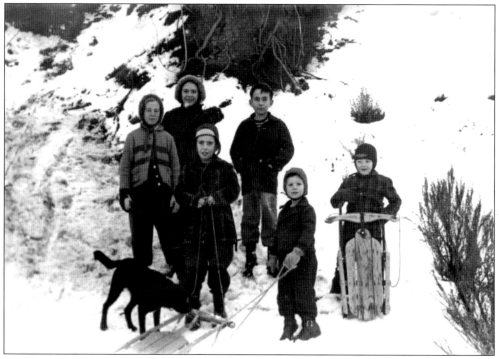

Winter entertainment was not a problem for the children in Hayden in the 1940s. The sparse automobile traffic allowed for safe roaming of the streets and alleyways. Here a group of children posed for a sledding picture at a hill in town. From left to right, they are Clara Nell Kline, Dollie Kline, unidentified, Roger Morris, Roger Lowry, and Dick Leslie.

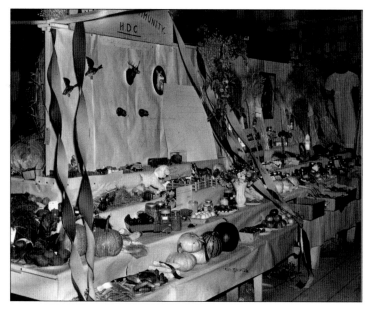

The Routt County Fair has always been an important showcase for local products and productivity. In this 1948 fair photograph, a number of items created by the local Home Demonstration Club fill a display area. Home Demonstration Clubs were usually comprised of local homemakers who wanted to learn new skills in cooking, sewing, and other household arts, and who also enjoyed getting together to socialize.

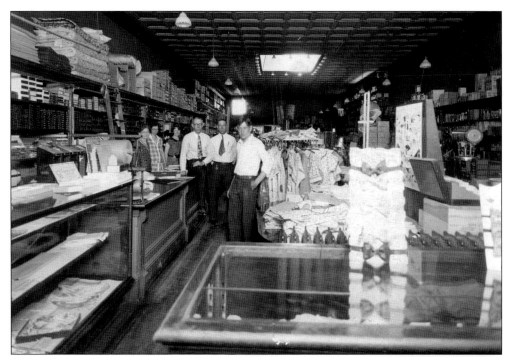

The Hugus store was sold to a group of local stockholders in 1919, and the Hayden Mercantile Company was organized. Earl Erwin was named manager in 1926, and he and his wife, Lorna, bought the business, known as the Hayden Merc, in 1943. From left to right in this late 1940s photograph are an unidentified person, Lorna Erwin, Margaret Whiteman, Earl Erwin, Stanley Brock, and Milton Coverston.

Every 10 years or so, the Hayden Congregational Church building was painted. In this 1955 photograph, Stanley Brock (back to camera) is making sure the job is done right. The stained glass window at the south end of the sanctuary was given by members of the Christian Endeavor youth group in 1903, when the church was under construction.

The first threshing machine in the Hayden area was built by Abram Fiske and his son Charles in 1884. The machine was on its way to the White River Indian Agency near Meeker when it was destroyed during the Ute uprising of September 1879. The Fiskes salvaged the machine's metal parts and rebuilt the thresher, which was used by area farmers for years. The building across the street in this c. 1957 photograph is the T and J Bar and Café. Christian Schaefermeyer built the west (left) part in 1917 and rented it to the U.S. Postal Department. In 1926, Shorty Huguenin remodeled the building and opened a restaurant. The name was changed to the T and J when Tom Scott and Jack Holderness bought Shorty's Café in 1944. When Forrest Markle owned it in the 1960s, it was called the Broken Drum. The building was torn down in 1994.

Seven

MOUNT HARRIS

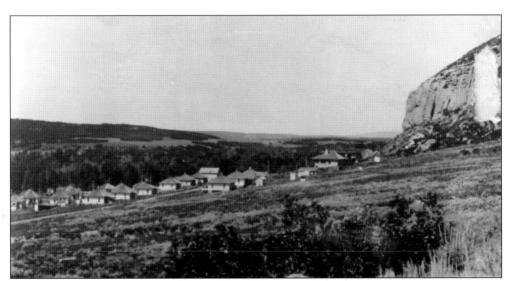

Seven miles east of Hayden, a roadside marker stands as a memorial to a coal-mining town known as Mount Harris. Three mines operated in this valley: the Colorado-Utah, or Harris mine; Victor-American's Wadge mine; and the Pinnacle-Kemmerer, or "P-K" mine. In 1920, Mount Harris was the largest community in Routt County. Today, only crumbling foundations remain of this once-vibrant town.

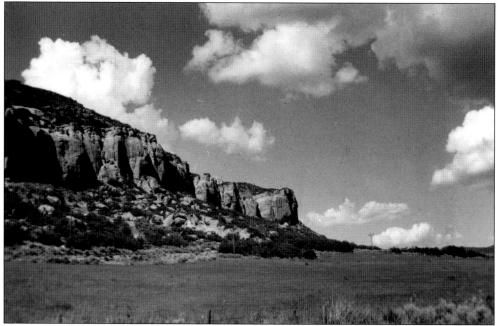

A massive sandstone bluff, known locally as Gibraltar Rock, overlooked Mount Harris. In previous centuries, this bluff was frequented by Native Americans, who left pictographs on its walls. Later, stone was quarried from this bluff and used for Mount Harris's business section. Miners' children played among the rocks of the bluffs and learned to avoid the numerous rattlesnakes found sunning themselves there.

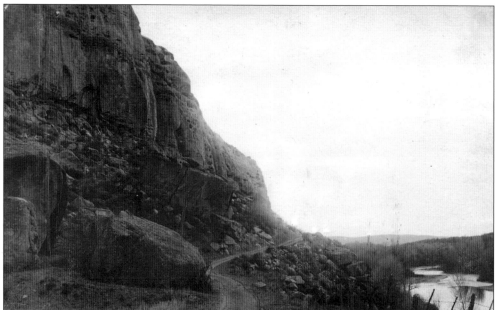

In 1905, a single track wound along Bear River Canyon, just east of the future site of Mount Harris. Road work was done with a pick and shovel and a little bit of blasting powder. In 1912 and 1913, the Denver, Northwestern and Pacific Railroad laid its rails between the road and the Yampa River. As the railroad inched further westward, coal camps began to spring up along the route.

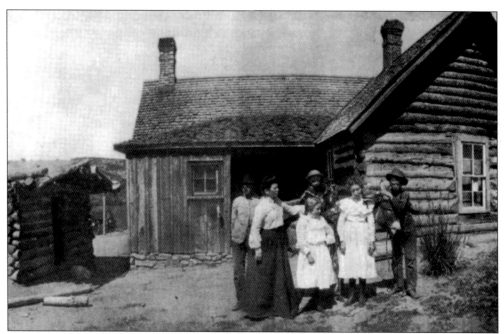

James Wadge from Devonshire, England, took up a homestead claim east of Gibraltar Rock in 1884. He then returned to England and brought back his bride, Sarah Jane. James opened a mine on Wolf Creek, and later operated a wagon mine south of the Yampa River, where the Colorado-Utah Company would locate their mine in 1914. In January 1915, Victor-American Fuel Company bought 1,600 acres that included the Wadge homestead.

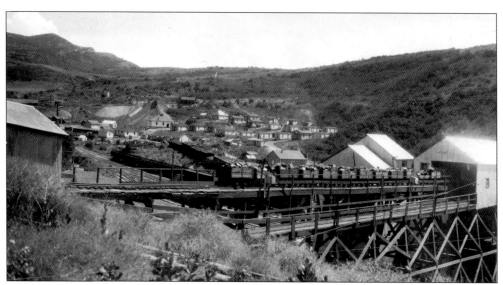

Victor-American Coal Company did not begin large-scale operations until 1917, when it decided to close its Pinnacle mine near Oak Creek and develop its property in the Yampa Valley. The Wadge mine was located south of the river, but the camp and tipple were in a draw north of the Harris camp, as shown here.

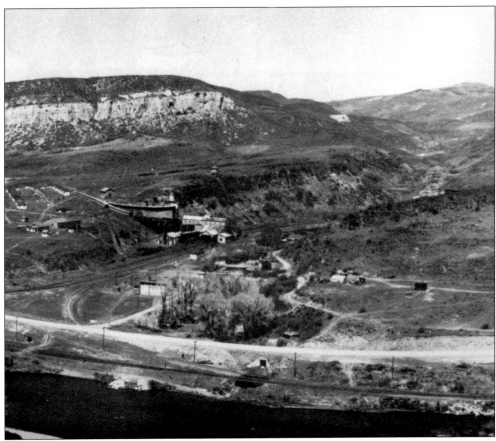

The Wolf Creek mine, located north of Wadge (upper left corner), was sold to International Fuel Company in 1915. This mine was known as the "P-K" after the Pinnacle-Kemmerer Fuel Company gained control in 1925. The operation was never very successful, and the mine, whose headquarters were in Kemmerer, Wyoming, closed in 1934.

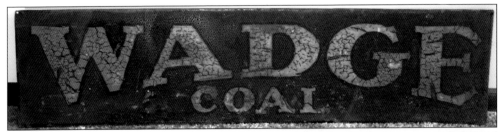

In 1915, Victor-American bought the Dawson tract, now the Nature Conservancy, and planned to locate its headquarters there. A scheme to establish the Dawson town site failed, but in the 1920s, the company tunneled under Gibraltar Rock and began mining the coal underlying the property, in what was known as the Wadge mine. On January 27, 1942, a methane gas explosion in one of the tunnels claimed 34 lives. Ten years later, the Wadge mine was closed.

In 1912, Iowa-born Byron Harris came out to northwestern Colorado looking for coal lands along the Moffat Road. Byron and his brother George formed the Colorado-Utah Coal Company and in 1914, purchased a tract of coal land south of the Wadge homestead. Within the year they opened a mine just west of the old Wadge tunnel and the town, Mount Harris, was formed. (Courtesy of Suzi Harris Crowner.)

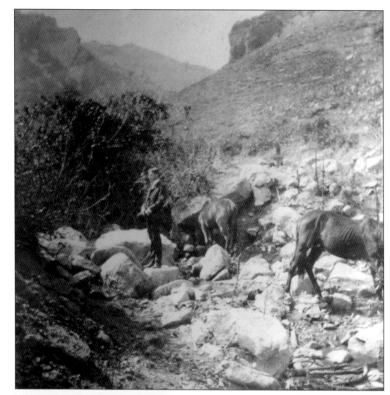

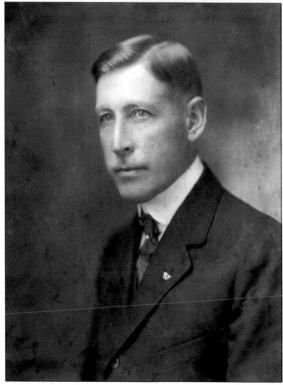

Byron Harris, resident manager for the Colorado-Utah mine, was undoubtedly one of the best-loved men in Routt County. His lively and kindly interest in his mine workers earned him a reputation as an honest, hard-working man. He died of a sudden illness in December 1926, at the age of 50, leaving behind a wife and two children. (Courtesy of Suzi Harris Crowner.)

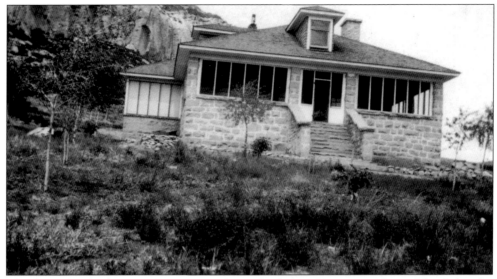

This house was built in 1916 as a summer home for George Harris, president of the Colorado-Utah company. Like the Mount Harris business section, the house was constructed of rock quarried from Gibraltar Rock. It sat on a hill above the town, but George Harris seldom occupied it. In 1918, it became the residence of D. L. Whittaker, the company doctor. (Courtesy of Suzi Harris Crowner.)

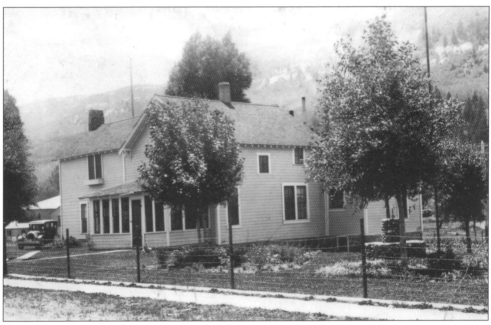

A residence for Byron Harris was completed in August 1914. It was said that every time a load of coal was shipped, Byron built another room. One of these additions was a living room with an oak floor made of wood that Byron's wife, Anne, got from her native Iowa. The chimney and fireplace were made of rocks from the Yampa River. (Courtesy of Suzi Harris Crowner.)

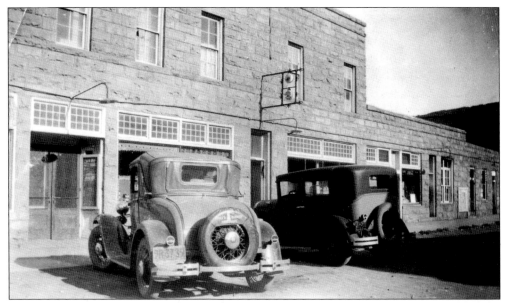

In 1915, Colorado-Utah built a large two-story building from native stone quarried from nearby Gibraltar Rock. The company store occupied both floors of the building, and a pool hall, barbershop, and meat market were on the first floor, north of the store. A hall above provided room for a picture show and dances.

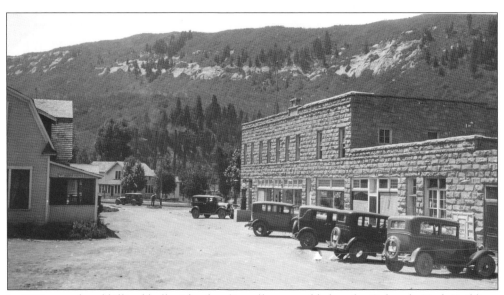

In 1917, a pool and billiard hall with a bowling alley was added to the Colorado-Utah Building. Two years later, a building was constructed on the north end for the Mount Harris post office. Once the post office moved into its new quarters, a drug store with a soda fountain occupied the former post office site.

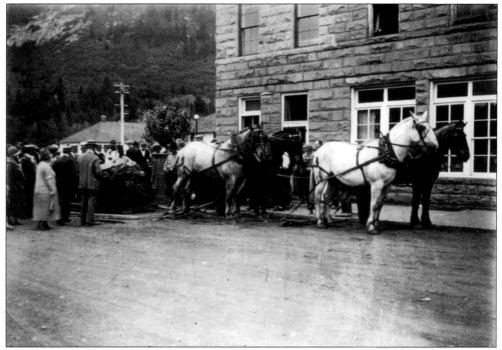

In this c. 1917 photograph, a group of Mount Harris residents gather around an enormous lump of coal that has been pulled into town. The mining company had a contest to see who could guess the correct weight of the coal. Unfortunately, no record exists to say what the weight of the coal was, or who made the correct guess. (Courtesy of Suzi Harris Crowner.)

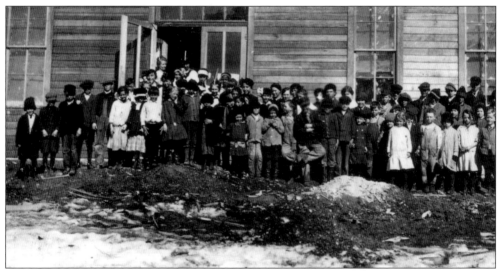

Classes in Mount Harris were held in a private home until 1916, when a two-story frame schoolhouse was completed. Contractors began breaking ground near the Victor-American company store in October 1915, and the school was dedicated in the spring of 1916. In 1921, a stone addition was completed, adding a room to each floor. On November 14, 1931, the school burned to the ground.

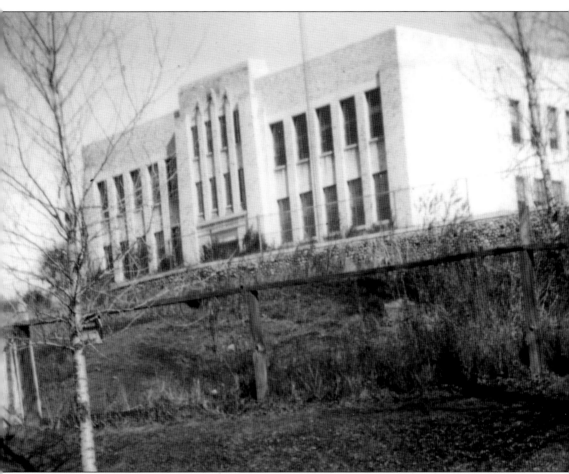

Despite the fire and much to the dismay of the students, school resumed only two days later on Monday, November 16. Classes for the first and second grade were held in the community church; the third grade met in the dining room of the Colburn Hotel, and the fourth grade met in the First Aid building. The upper grades, fifth through eighth, were in the Liberty Theatre. The new school was built of bricks made on the Harry Allen ranch, just west of Gibraltar Rock. The new building had eight classrooms, a teachers' lounge, woodworking shop, gymnasium, and maple floors throughout. The last eighth-grade class graduated on May 19, 1958, and five days later, the contents of the school were sold at public auction. The sale of the schoolhouse, furniture, and five-room teacherage netted $2,610. (Courtesy of Doris Rutherford.)

The school was sold to George Watts of Hayden. According to the terms of the sale, the building was to be leveled after all salvageable materials had been removed. George and his wife painstakingly removed the three statues that had graced the front of the school for 32 years. The statues, representing Literature, Science, and Art, were donated to the Hayden Heritage Center. When the building was torn down, the bricks made on the Allen ranch were not worth salvaging because they disintegrated.

The two-story building seen here is the Liberty Theater. When it was completed in 1917 just before Christmas, it had no name. The management offered $5 in Thrift stamps and free admission to a movie to the person who suggested the best name. The winning name, "Liberty," was Clyde Young's suggestion.

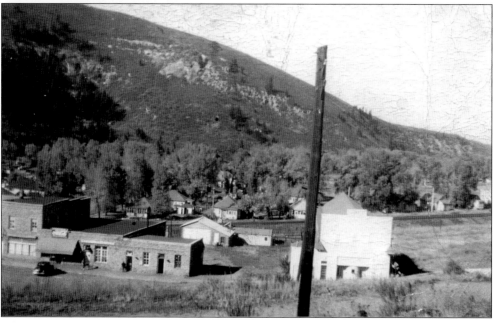

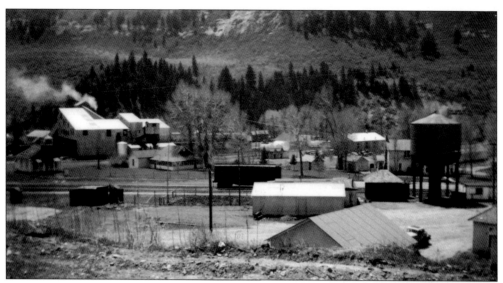

A. S. Miller supervised the construction of a railroad water tower in 1918. The 50,000 gallon tank was retired in 1953, when the railroads switched to diesel fuel. The white building to the left of the water tower is a boxcar depot that had served as Hayden's depot until a new brick depot was built in 1918.

The Colorado-Utah Mining Company cleared the brush and trees and began to construct houses on the south side of the Yampa River in 1918. A cable bridge was built to provide access to the new houses. In 1925, 30 houses of two or three rooms were built across the river for bachelor miners, as well as African Americans and Hispanics, who were subject to the segregation of that time.

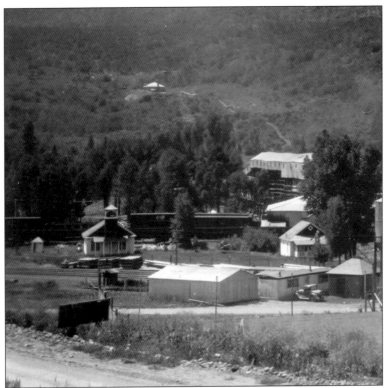

A community church was built on a triangular plot southeast of the Byron Harris home in 1920. It was liberally supported by the coal companies, and boasted 86 members by the time it was completed. Charles Youberg bought the building in 1958, and gave the church's bell to the Hayden Congregational Church. He sold the building to the local American Legion post for use as a legion hall in Hayden.

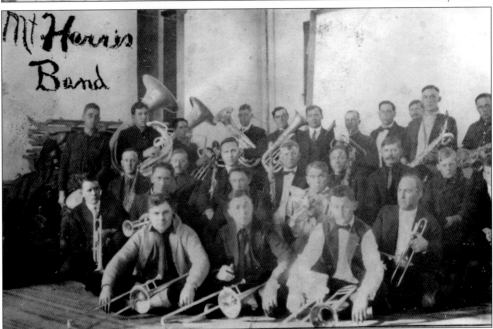

Mount Harris never did anything halfway. In January 1921, they formed a brass band, ordered $2,000 worth of instruments, and brought Ed Mahaffey from Des Moines, Iowa, to be the director. The instruments, which ranged in size from cornets to tubas, arrived at the end of January, and by April, the band was giving concerts.

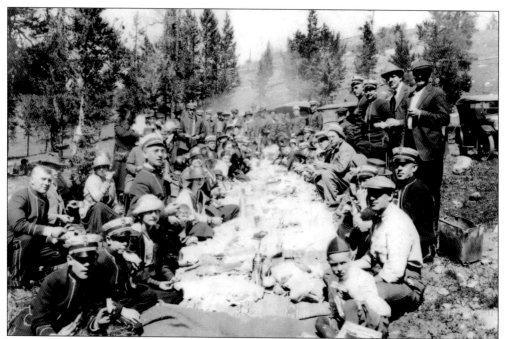

The members of the Mount Harris Band hosted a picnic and fish fry on Rabbit Ears Pass in September 1921, and invited all of Routt County to join them. The men who went the day before to catch fish had no luck, but no one went hungry. Some 34 carloads of people, about 200 in all, enjoyed the festivities.

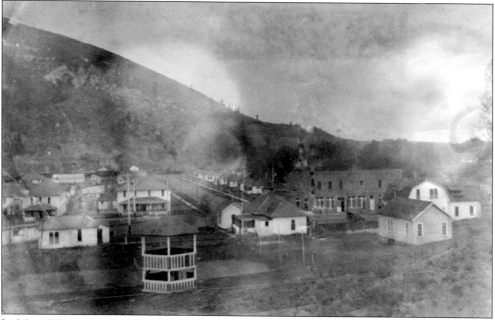

In May 1921, a two-story bandstand was built in a wooded area next to the ballpark. It was a round, wooden structure with pillars that supported the second floor and roof. Benches were built around the inside on both floors, and a stairway led to the top level. In the late 1920s, the band director was Joe Cuber from Hayden. (Courtesy of Tracks and Trails Museum.)

The Yampa River frequently overflowed its banks during spring runoff, and the miners who lived near it had to move to higher ground. The bridge in this photograph was known as the "swinging bridge" because it swung up and down after an automobile crossed it. Children would wait until the automobile passed, and then would try to keep their balance on the still-swaying bridge.

In winter, the baseball field was flooded and transformed into a large skating rink. Skating was thoroughly enjoyed by both children and adults. In 1921, lights were added, and young people from nearby communities came to experience the novelty of skating on the floodlit ice at night.

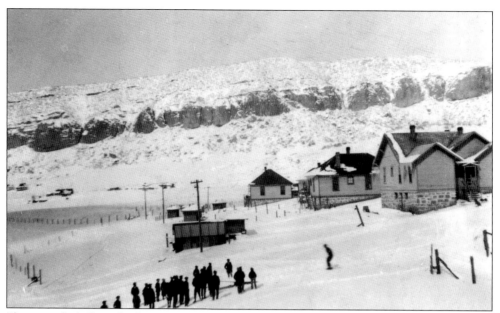

Skiing on the hill north of town was another favorite winter pastime. The older boys would spend days packing the snow and building a jump. Skis, for the most part, were homemade because few families could afford to buy them. Rubber bands were cut from discarded inner tubes and used for binders.

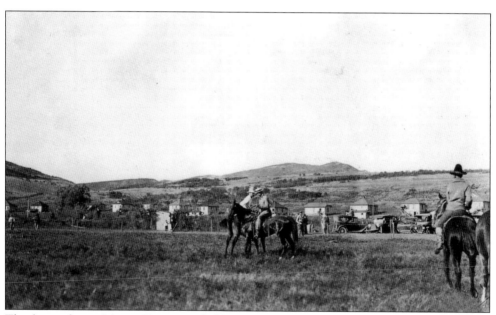

The first rodeo at Mount Harris was held on July 3 and 4, 1921. It was part of a celebration sponsored by the Mount Harris Athletic Club, and consisted of bucking contests and horse races. A crowd of 1,200 attended the first day. It was an annual event for three years before the rodeo grounds had to be abandoned to make room for more houses.

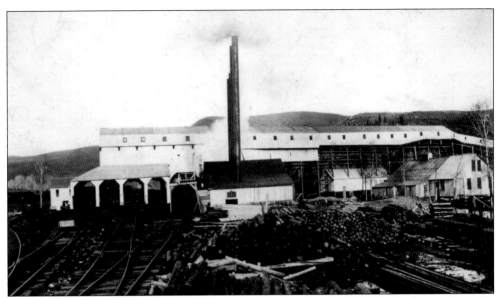

Coal from the Colorado-Utah mine traveled in tram cars across a 400-foot bridge to the tipple on the north side of the river. Here the cars were tipped, and the coal dropped into the railroad cars below. The tipple in this photograph was replaced by a new one in 1925.

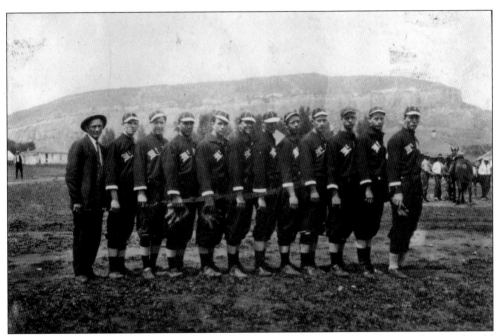

This photograph of Byron Harris (left) and the Mount Harris baseball team was taken on the old baseball field at Mount Harris. In 1937, the field and grandstand were moved to the center of town, and a bath house for the miners was built on the old site. The new grandstand was completely screened so the spectators would not get hit by a foul ball.

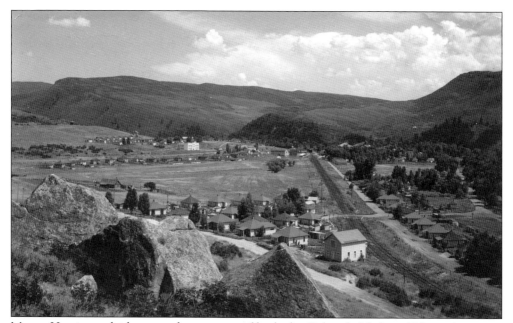

Mount Harris was laid out on the property of both the Colorado-Utah and Victor-American companies. The Harris miners lived along the river in white houses with grey trim, and the Wadge miners lived up on the hill. The two camps were so close together, they appeared to be one town. The wide field in this early 1930s photograph was an ideal place for a baseball field.

Mount Harris women loved to meet for educational purposes, which provided them with social contact as well as practical information and hands-on experiences. Here in 1934, women from the Home Demonstration Club display the racks and shelves they have made. The Home Demonstration Clubs were operated under the auspices of county extension offices throughout the state.

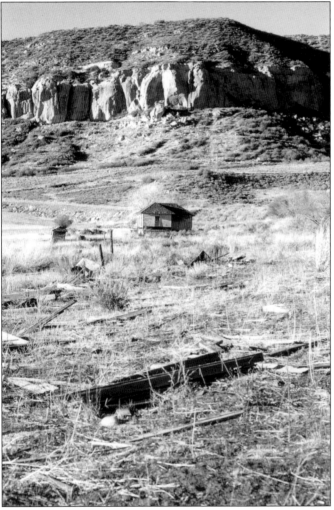

Mount Harris children enjoyed the privileges of small-town life and a close-knit community. Ramsay Harris (center), son of the mine manager Byron Harris, grew up playing with the rest of the coal miners' sons. These children formed strong attachments to their community and long after the town was gone, still met for yearly Mount Harris reunions. (Courtesy of Suzi Harris Crowner.)

Mount Harris, the home of three coal companies, was one of the bright spots in Routt County for 44 years. It was the most modern and up-to-date coal camp in the Rocky Mountains. Nevertheless, in 1958, it became a ghost town in a matter of weeks. When the photograph at left was taken almost 40 years later, only a single derelict building remained.

Eight

PEOPLE

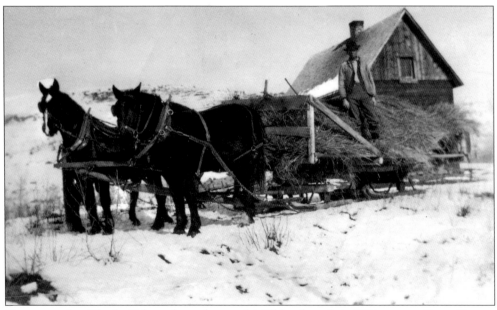

Pioneer rancher Charles Fulton, shown here on his Elkhead ranch in 1924, came to Routt County in 1901. He married Paroda Bailey in 1908, and the couple had six children. They moved to Hayden in 1924 so their children could attend school. Charles and Paroda spent the rest of their lives in the community.

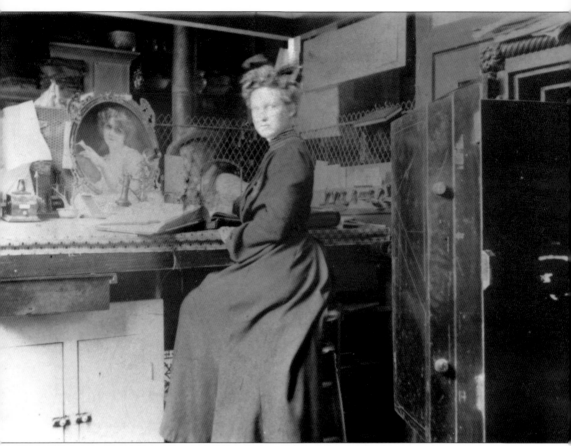

When Florence Wheeler arrived in northwest Colorado in 1901, she only planned to spend the summer. Instead, she became a member of the fledgling Hayden community and spent the next 70 years watching it grow. Florence was there when the town incorporated and watched the first train come chugging into town. She witnessed the construction of Hayden Congregational Church, Hayden Union High School, and Solandt Memorial Hospital. She worked as a bookkeeper for the Hugus store in Hayden before marrying Alva Jones in 1906. The couple had two children, Melvon "Casey" Jones and Ayliffe Jones Zehner. A dedicated homemaker, Florence was involved in church and community activities and was a charter member of Hayden Chapter 99, Order of the Eastern Star. She also had a millinery shop in the Starr Mercantile, worked in the post office, and helped with the school lunch program. Florence Wheeler Jones is just one of many people who were passing through town and chose to make Hayden their home.

Louise and Elmer Yoast were living in Dunkley when they posed with their son, Raymond, for this *c.* 1918 photograph. Elmer died in 1925, and Louise worked as a telephone operator in Hayden and baked pies for Shorty's Café until she married Bob Hope in 1928. Her son, Raymond, purchased the Hayden Valley Dairy and operated it until 1971.

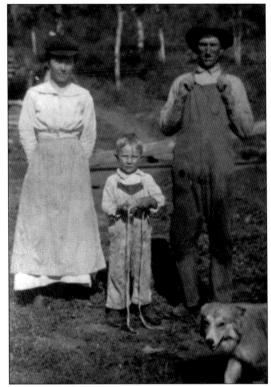

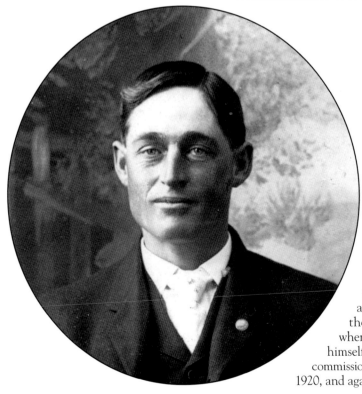

Henry Summer came from Sidney, south of Steamboat Springs, in 1907. His brother-in-law, George Kleckner, had a grocery store in Hayden, and Henry was in charge of the meat market until 1914, when he went into business for himself. He served as Routt county commissioner for 20 years, from 1917 to 1920, and again from 1933 to 1948.

Ruth Bodfish (left) and Delcina Neilson of East Hampton, Massachusetts, came to Hayden in 1917. The two friends had been hired to teach at the Elkhead School north of Hayden. Delcina Neilson married Bryon Shelton's son, Sam, in 1918, and a year later, Ruth Bodfish married Elkhead rancher Edgar Fulton.

Eunice Pleasant, shown here at the school where she taught, was another Elkhead teacher who married a local boy. She came to Craig in 1918 to visit her brothers and was offered a teaching position at Elkhead School. In 1920, she married part-time Elkhead homesteader and Hayden lawyer Ferry Carpenter. As a member of the Hayden Women's Club, she helped establish the Hayden library and later wrote a weekly column for the *Routt County Republican*.

Al Sheme moved to Hayden in 1949 and was employed by the Osage Coal Company. He bought Tri-State Lumber in 1958 and operated it as Hayden Lumber and Supply until his death in 1969. Shown in this 1954 photograph are Ellen and Al Sheme and their children, Sherrie and Thomas. (Courtesy of the Folley Family.)

Dr. Ligon Price, seen here in a 1967 photograph, joined Dr. William Sloan's Hayden–Mount Harris practice in 1938. Although they were hired by Colorado-Utah, both doctors were on the staff of the Solandt Memorial Hospital and had an office in Hayden. When Sloan retired in 1949, Price took over the practice. After Ligon retired in 1957, he and his wife, Lucille, moved to Aspen.

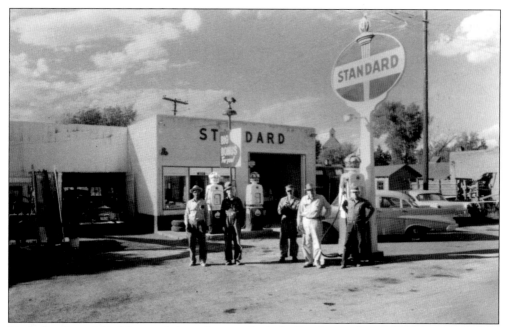

Linde Sundberg (third from right) was born in Linhult, Sweden, and came to the United States when he was 19. In 1929, he married Lucille Stratton, and two years later, he opened Linde's Service Station in Hayden. This was at the height of the Depression, and the town already had three service stations. However, the product of Sweden outlasted his competitors, and he remained in business until 1972.

Earl Parfrey came to Routt County in 1918 and homesteaded at Pagoda. He taught local rural schools and in 1937 bought a grocery store in Hayden. Earl was more of a geologist than a grocer, and his store eventually became his rock shop. He began writing a column, "Rock Hound," for the local newspaper in the 1950s. Local children recall coming into his store with rocks to show Earl. Sometimes he would trade a small piece of candy for the rocks; other times he would send the children out again to find a better one.

Truman Leslie, a native of Russellville, Missouri, and Velora Musgrave from White City, Kansas, met in Steamboat Springs and were married there on March 5, 1937. At that time, Truman was pharmacist for Chamberlain-Gray drugstore, and Velora was a linotype operator for the *Steamboat Pilot*. The Leslies came to Hayden in 1943 when they bought Brock's Pharmacy. In 1974 they sold the business to Joel Hollatz.

Daughter of Truman and Velora Leslie, Jan Leslie peers mischievously back at the camera in this *c.* 1940 photograph. Intent on catching a "pider" on the wall, Jan was as meticulous about detail at this young age as she is today. Author of three historical books about her hometown and county, Jan Leslie is regarded locally as the leading authority on anything related to Hayden's history.

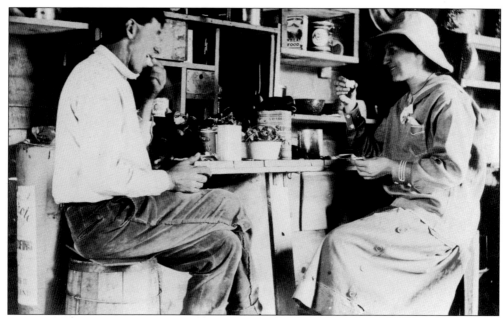

When Cliff Fulton was killed by a neighbor in 1914, his brother Ed came from Ohio to carry on with Cliff's ranch at Elkhead. Ed, shown here with his sister, Elizabeth, in this c. 1911 photograph, continued to develop the ranch and build up Cliff's herd of cattle until two years before his own death in 1943.

Max Dufford, seen here with his wife, Lola, was the last station agent at the Hayden depot. He and his family came from Orestod, Colorado, where he had been station agent in 1947. Their children, Laurene and Max Jr., graduated from the Hayden Union High School. When the depot closed in 1968, the Duffords moved to Northglen, Colorado.

Jackie Morgan was born in Sterling, Colorado, where her father was a telegraph operator for the railroad. In 1960, Jackie's husband, Don, was hired as principal of the elementary school in Hayden, and Jackie became an English and speech teacher in the high school. Her first speech students qualified for the Colorado State Speech Meet in 1962. Jackie was involved in many community clubs and organizations. She passed away on June 8, 2001, after spending more than 40 years serving the Hayden community.

Joseph Lasnik was born near Walsenburg, Colorado, in 1914. After graduating from high school in Erie, Colorado, he studied mathematics and physics at the University of Colorado. In 1943, he was drafted and served with the 1065th Engineers in Europe. Joe came to Hayden in 1946 to visit his brother, Ed, and stayed on to work in his brother's mine. Five years later, in 1951, he married Allie Kleckner. (Courtesy of Judy Poteet.)

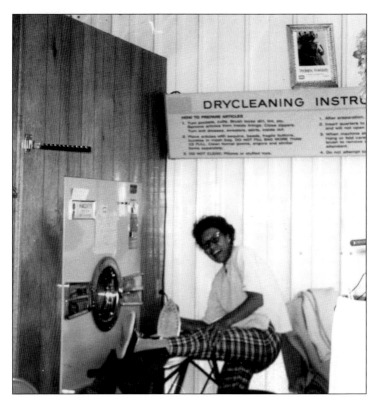

Allie Lasnik, shown here in the Park Laundry in 1966, was born in a cabin near Bears Ears northwest of Hayden in 1908. She was 12 years old when her mother, Ida, died. Her father later married Cora Anderson, the widow of his partner in the Hayden Livery barn. Allie and her husband, Joe, were part-owners of the Park Laundry located across the street from the park on Third Street. (Courtesy of Judy Poteet.)

Jacquie Boyd (right), seen here with Jean Scott, came to Hayden in 1978 when her husband Joe was appointed president of the Yampa Valley State Bank. In 1979, she became librarian at the Hayden Public Library, which was located in the former Northwestern Colorado Press building on West Jefferson Avenue. Jacquie's efforts to improve the library resulted in the construction of the present facility in 1984. The introduction of computers quickly filled the space, and the Town of Hayden approved the construction of an addition in 1998. This dynamic lady also found time to serve as treasurer of the West Routt Health Council, a non-profit group that established The Haven, an assisted living facility in East Hayden. She was also on the advisory board for Colorado Northwestern Community College, and was moderator for the Congregational Church. Jacquie Boyd retired in 2004 after serving the Hayden community for 25 years.

Harold and Mary Denker moved to Hayden shortly after their marriage in 1947 to take up wheat farming. They raised two children, Jim and Joyce, in addition to maintaining an active involvement in the community. Mary, who was a homemaker, avid gardener, and sports enthusiast, passed away on January 9, 2005, after almost 57 years in Hayden.

Bobby Robinson Sr. was born in 1910, and grew into a man with greatly varied interests, talents, and abilities. Bobby went into business for himself doing construction work after World War II, and developed a successful company. Shown here with a pair of spurs he made, Bobby's hobbies ranged from antique and vintage car collecting to hunting and fishing. He devotedly served the community for many years, and aside from his phenomenal kindness, Bobby is best remembered for his traditional barbecues where he served up his secret "Swamp Sauce."

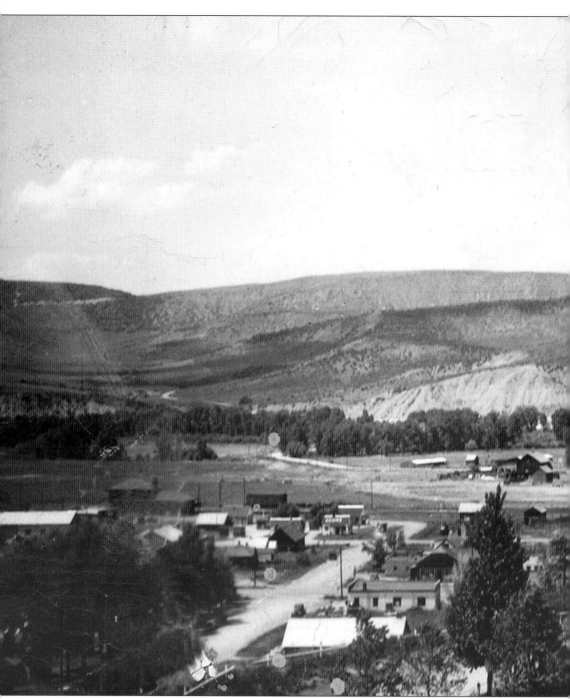

This panoramic view of Hayden was taken in the late 1920s or early 1930s, and gives a view of the town that is much the same as it is today. The hospital building (right) now serves the community as a medical center and office complex. The agricultural and rural land just to the north of town is largely unchanged. The train depot (left rear) now serves as the home for the Hayden Heritage

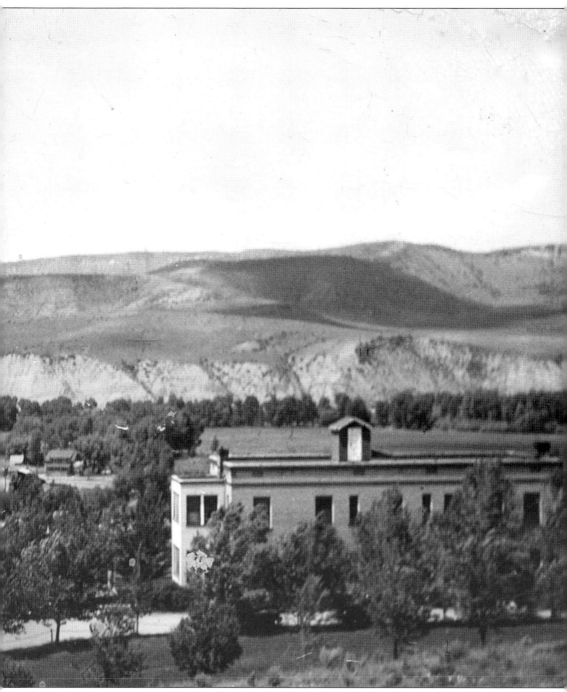

Center museum. Downtown Walnut Street is in the process of being designated a historical district with most of its original buildings still standing and in use. Old-timers mingle with the new residents as they work together to maintain the unique sense of spunk and individuality that gives this town its own flavor.

BIBLIOGRAPHY

History of Hayden and West Routt County 1887–1989. Dallas, TX: Curtis Media Corporation: 1990.

History of West Routt County, Colorado. Dallas, TX: Curtis Media Corporation, 1995.

Johnson, Ruth Douglas. *Mt. Harris Echoes.* CO: self-published, 1979.

Leslie, Jan. *Anthracite, Barbee, and Tosh.* Hayden, CO: Walnut Street Publishers, 2005.

Routt County Republican.

Routt County Sentinel.

Towler, Sureva, and Jim Stanko. *Faster Horses, Younger Women, Older Whiskey.* Steamboat Springs, CO: White River Publishing Company, 1996.

White, Stefka. "*In the Shadow of the Rimrocks.*" Hayden, CO: *The Hayden Valley Press,* 1990–1994.

About the Hayden Heritage Center

The Hayden Heritage Center Museum, located in Hayden, Colorado, occupies a lovely brick railway depot that served Hayden and West Routt County as the region's travel and transportation center for 50 years. The depot building, built in 1918, is listed on the National Historic Registry. After the last passenger train pulled away from the station in 1968, the depot remained empty for a number of years. The museum was established at the depot in the 1980s and in addition to hosting exhibits highlighting the history of the area, it also acts as a resource for genealogical and local historical research. The museum may be reached at:

P.O. Box 543 Hayden, CO 81639
970-276-4380
heritagemuseum@nctelecom.net

www.arcadiapublishing.com

Discover books about the town where you grew up, the cities where your friends and families live, the town where your parents met, or even that retirement spot you've been dreaming about. Our Web site provides history lovers with exclusive deals, advanced notification about new titles, e-mail alerts of author events, and much more.

MADE IN THE USA

Arcadia Publishing, the leading local history publisher in the United States, is committed to making history accessible and meaningful through publishing books that celebrate and preserve the heritage of America's people and places. Consistent with our mission to preserve history on a local level, this book was printed in South Carolina on American-made paper and manufactured entirely in the United States.

This book carries the accredited Forest Stewardship Council (FSC) label and is printed on 100 percent FSC-certified paper. Products carrying the FSC label are independently certified to assure consumers that they come from forests that are managed to meet the social, economic, and ecological needs of present and future generations.

FSC
Mixed Sources
Product group from well-managed forests and other controlled sources

Cert no. SW-COC-001530
www.fsc.org
© 1996 Forest Stewardship Council

Find Your Place in History.